Perspective for Interior Designers

Perspective for Interior Designers

BY JOHN PILE

WHITNEY LIBRARY OF DESIGN
An imprint of Watson-Guptill Publications/New York

First published 1985 in New York by Whitney Library of Design,
an imprint of Watson-Guptill Publications,
a division of Billboard Publications, Inc.,
1515 Broadway, New York, N.Y. 10036

Library of Congress Cataloging in Publication Data

Pile, John F.
 Perspective for interior designers.

 Bibliography: p.
 Includes index.
 1. Perspective. 2. Interior decoration. I. Title.
NC750.P6 1985 729 85-13925
ISBN 0-8230-7420-X

Distributed in the United Kingdom by Phaidon Press Ltd.,
Littlegate House, St. Ebbe's St., Oxford

Manufactured in U.S.A.

First Printing, 1985

1 2 3 4 5 6 7 8 9/89 88 87 86 85

ACKNOWLEDGMENTS

The author wishes to express appreciation to the designers and architects who have provided drawings and permission to reproduce drawings and photographs essential to the completion of this book. In particular, the following individuals have made drawings available for inclusion:

Norman Diekman

Joseph Paul D'Urso and
David Applebaum of his office

Irving Harper

Jean-Pierre Heim

Robert A. M. Stern, FAIA
and William T. Georgis,
Thomas A. Kligerman,
and Graham Wyatt of his office

Lebbeus Woods

Ming Wu of the office
of Kohn, Pedersen, Fox

Victor Yohay

The following institutions, organizations, and firms have been helpful in providing material and permission for publication:

Academy Editions, London

Architectural Book Publishing Company

Studio Architetti BBPR (Banfi,
Belgiojoso, Peressutti, and Rogers)
and Enrico Peressutti

Dover Publications

Kohn, Pedersen, Fox, Architects

Herman Miller, Inc.

Museum of the City of New York

The Museum of Modern Art, New York

Skidmore, Owings & Merrill, Architects,
New York, and Natalie Leighton
of that office

Steelcase Inc.

The Frank Lloyd Wright Memorial
Foundation at Taliesin West
and Bruce Brooks Pfeiffer

All drawings and photographs not otherwise credited are by the author.

The encouragement, support, and help of Stephen Kliment as editor has been vital in bringing the book to completion. Appreciation is also expressed to Naomi Goldstein for editorial help and to Robert Fillie for dealing with difficult problems of book design and production.

A final note of appreciation is offered posthumously to the late Professor George Baumeister of the School of Fine Arts of the University of Pennsylvania who first introduced the author to the mysteries of perspective drawing.

Contents

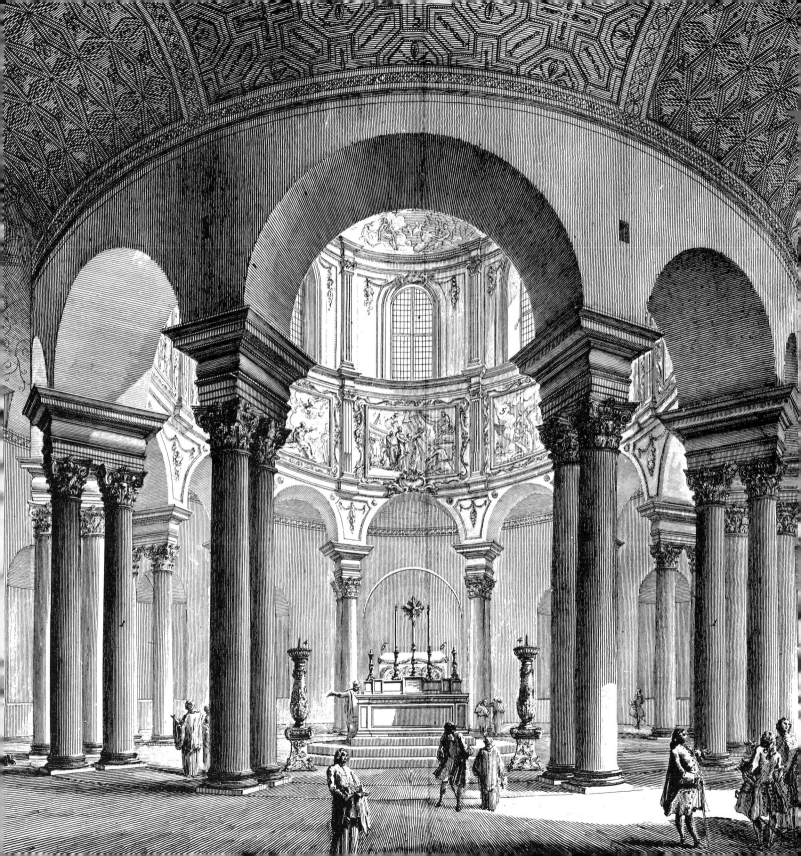

Introduction

FROM PRIMITIVE TIMES through the Middle Ages, artists struggled with only limited success to find a way to show scenes as they actually appear to the human eye. People, animals, and single objects were drawn with striking realism, but buildings and spaces within buildings were represented in ways that now seem strange and quaint. It was not until the Renaissance that a more scientific approach to drawing applied the concepts of geometry to the making of the kind of realistic view that we now call "perspective." As the artists of the Renaissance learned this methodology, it became possible to draw and to paint exterior and interior views in a way that we now can call "photographic."

The development of lenses, the camera obscura (with pinhole and later with glass lens), and finally the invention of photography gradually made perspectives so commonplace that they now seem to be the only truly "realistic" way of presenting the world. For architects and designers, perspective drawing has become a basic tool for showing design proposals in a way that is fully understandable to a public that is not prepared to decipher architectural plans, elevations, and sections.

Learning to make perspectives is a part of every beginning design curriculum. Unfortunately, it is the experience of many design students that the way in which perspective is usually taught (as a branch of descriptive geometry involving a confusing tangle of points, lines, and planes) makes the subject something of a mystery and an obstacle in the way of mastering design drawing. The fact that the subject is often presented in an abstract way before it is actually needed in design work also contributes to making the technique hard to put into daily practice.

Design instructors find it necessary to organize "perspective clinics" to try to aid students who are trapped in a hopeless struggle with a technique remembered only dimly from an early "basic" course. The matter is also made more difficult both in introductory courses as well as in later remedial efforts (and, all too often, in books on the subject) by a common urge to introduce shortcut methods using fixed viewpoints or other formulas that are supposed to make things easier. In

practice, shortcuts are usually only applicable to a limited range of situations and tend to delay the student's mastery of the basics.

If all this is true of perspectives of objects and buildings, interior perspectives seem to present an even more troublesome problem. Methods are usually presented in ways that deal with a solid object viewed from outside. When the view moves to the inside of a hollow space, all the rules seem to be turned inside out in a confusing way. Students and beginners in interior design seem to be plagued by drawings of strangely distorted spaces in which furniture floats with legs suspended above the floor or with round table tops rolling downhill in a distressing and mysterious way. Methods in which a nightmare of little squares are suggested as an aid to dealing with these problems only make the matter worse.

Interior perspective drawing can be learned fairly easily and can even be self-taught if shortcuts are put aside and the basic method mastered. It is the purpose of this book to offer such a basic method that will serve every interior design drawing need and that can be learned in a very short time. It is assumed that the reader is already familiar with plan, section, and elevation drawings and has fluency in the use of pencil and basic drafting tools. Any memories of shortcut methods, gadgets, or charts should be put aside while the method described here is practiced.

Reading alone is not likely to make the technique familiar or easy. Instead, it is suggested that the reader begin at once at the drafting board with a perspective layout and follow the steps described in this book as closely as possible. At first it might be best to choose a simple imaginary space similar to the one used in the illustrations in Chapters One and Two. Be sure, however, to incorporate enough differences in spatial form, dimensions, and details of design to make a fresh problem. Next, try several different spaces in different angular positions and then try to draw an actual space (existing or planned) from real plan and elevation drawings. Making a measured plan of a familiar

room (one's own living room, for example) and then drawing several perspectives from different points of view will help to make the basic method become easy and natural.

Once the basic method is familiar, the various special situations (such as one-point perspective) should be tried out with the more difficult problems of drawing circular forms, irregular spaces, and spaces containing furniture in various positions. It may be tempting to leave some of these matters until needed for an actual project, but the sense of mastery that comes from having dealt with every situation in advance is well worth the time it takes to produce a variety of layouts. Setting out to practice some particularly difficult problems—for example, drawing a spiral stair in an irregular room with some mirrored wall surfaces—is a good way of building confidence in one's ability to deal with any problem, no matter how complex.

Analysis of published perspective drawings, along with study of photographs and the way in which the camera generates perspectives, can also be helpful. This book does not attempt to deal with techniques of rendering, which may be needed to convert a line perspective into a presentation drawing. Many excellent books deal with this subject, and several are suggested in the selected bibliography offered.

All perspective drawing makes use of the commonly observed phenomenon that distant objects appear smaller than objects of the same size seen close up. The related way in which horizontal lines seem to slope up or down is not quite as obvious, but is easily demonstrated by the often illustrated view of a road or railroad tracks diminishing and seeming to disappear in the distance. These phenomena result from the fact that the lens of the eye projects an image onto the retina that produces a perspective because of the geometry that the laws of optics generate. By presenting to the eye an image on a flat surface in which these optical effects are re-created, a retinal image is produced that corresponds to the image that would be generated by reality.

The geometric means for creating this illu-

sionistic image were discovered and codified by artists during the Renaissance, and it is their system of drawing horizons and vanishing points and measuring out diminishing units of space to give the illusion of distance that is the basis of perspective drawing today. Once learned, the logic of the system becomes self-explanatory, but to the uninitiated it remains an almost magical trick by means of which a few oddly placed lines can suddenly create the illusion of three-dimensional reality. Once mechanical perspective is learned, freehand perspective becomes easy to master and drawing from reality in accurate perspective even easier.

Modern computer drafting systems now offer programs that can create perspective images almost instantly from the data provided by plans and elevations. These techniques make it possible to change viewpoint, move objects about in a space, and create effects of movement through a space simulating a moving picture. All such computer techniques are based on programs that translate the geometric basis of perspective into computer language and memory. However, the equipment needed is complex and expensive; the programs are highly specialized and require a great deal of computer capacity. Thus, the ability to accomplish in a few minutes with one's own hands, pencil, and paper the same tasks that a powerful computer will find demanding remains a valuable skill and a source of satisfaction. Computer-generated perspective layouts will probably soon become commonplace, at least in large design offices. But the designer's hand and pencil remain the tools most likely to produce drawings that are personal, expressive, and at best, works of art.

TOOLS

Perspective drawing does not require special tools or equipment other than the standard drafting materials. A fairly large drawing board is a convenience, since vanishing points are often far apart and may fall beyond the edge of a small board. A parallel rule straightedge is often not as convenient as an old fashioned T-square, since many lines will angle up or down. If a parallel rule is in place, it can be used for horizontals and to hold triangles to establish verticals, but it will be helpful to have a fairly long straightedge (T-square or plain rule) at hand as well.

Ordinary drafting triangles will serve well—a large one is useful at times. Ellipse templates can be helpful when circular forms are to be drawn. The maximum number of sizes and proportions that can be afforded will give the widest range of uses. French curves will help in drawing ellipses not available as templates.

Yellow (cream) tracing paper is the best material for layout and is often used in layers. A good grade white tracing paper is needed for more finished drawings. "Clearprint" is a favorite brand. A good assortment of pencils (2H, H, F, HB, and 2B will serve), a roll of drafting tape, and a few pins are the only other materials needed.

DEFINITIONS

Special terms used in this book are generally defined when they are first used. A few basic terms are listed here for easy reference.

Cone of Vision. The cone (a V in plan) within which a clear view can be had from a fixed viewing position. It is usually considered to have an angle of 60°, sometimes increased to 90° at the cost of some distortion.

Ellipse. The geometric figure that best represents a circle seen in perspective at an oblique angle. Ellipses must be correctly drawn to avoid distortion.

Height Line. The vertical line along which true heights can be measured; usually the backmost corner of an interior space.

Horizon. A horizontal line passing through a perspective at eye level. Vanishing points are normally placed on the horizon.

Major Axis. The longest dimension of an ellipse. When a circle in a horizontal plane is placed in perspective, its major axis must be horizontal.

Minor Axis. The shortest dimension of an ellipse. It is always at right angles to the major axis.

One-Point Perspective. A perspective in which one system of parallel lines in plan are parallel with the picture plane. Only one vanishing point can be used, since the other vanishing point(s) are at infinity.

Picture Plane. The imaginary vertical plane on which the perspective image is projected. It is represented in plan by a horizontal line.

Sight Line. A construction line, sometimes called a "ray," coming from the station point and passing through a particular point in plan. It is then extended to the picture plane to locate that point horizontally in the perspective.

Station Point. the location of the imagined viewer whose image of the space will be represented in the perspective. It is represented by a point in plan, which is usually circled and marked SP.

Three-Point Perspective. A perspective in which the imagined viewer looks upward or downward instead of on an exact horizontal. This will cause vertical lines to appear slanted, moving toward a third vanishing point located above (when looking upward) or below (when looking downward) the perspective being drawn. Three-point perspective is rarely used in architectural drawing; it is usually preferable to see all verticals in actuality represented as verticals in perspective.

Two-Point Perspective. A perspective developed from a plan placed at an oblique angle to the picture plane so that two vanishing points, one point at left and one point at right, are developed.

Vanishing Point. A point toward which a particular system of horizontal lines appears to converge. Normally, vanishing points lie on the horizon. They are marked by a point, which is usually circled and labeled VP, or VPL and VPR (for left and right), in two-point perspectives.

Perspective for Interior Designers

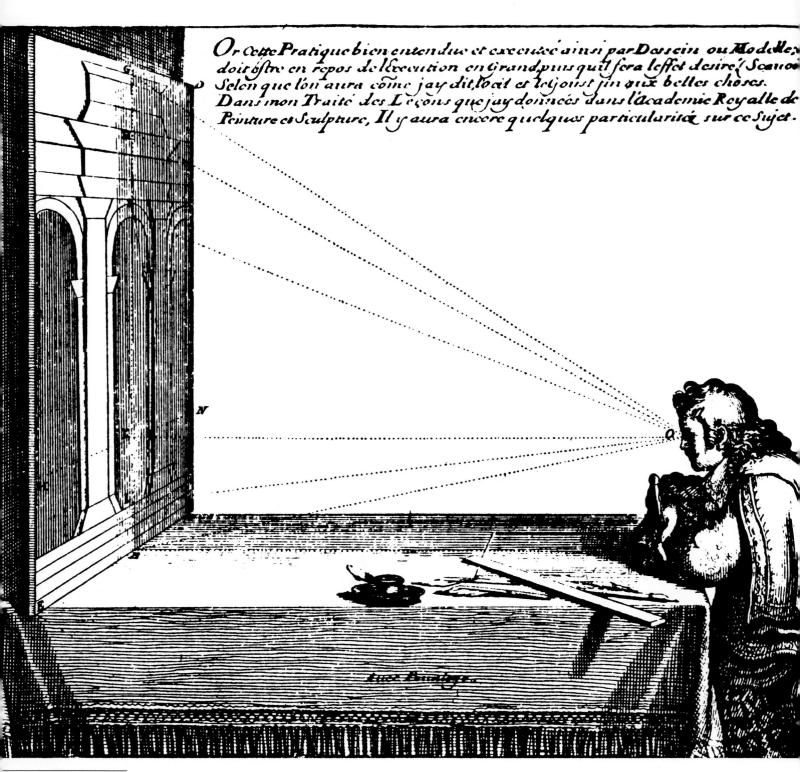

Or Cette Pratique bien entendue et executée ainsi par Dessein ou Modelle doit ôstre en repos de l'Execution en Grand, puis qu'il sera l'effet desiré, Scauoir Selon que l'on aura côme jay dit, l'oâl es teïouïst fin aux belles choses. Dans mon Traité des Leçons que jay données dans l'Academie Royalle de Peinture et Sculpture, Il y aura encore quelques particularité sur ce Sujet.

Basic Method

An engraving from an early "method," Traité des Manieres de dessiner . . . *by Abraham Bosse, published in Paris, circa 1688.*

A NUMBER OF METHODS for developing perspectives have been devised over the years. The method most useful to architects and interior designers is usually called the *revolved plan method*. Designers work with plans, tend to think in terms of plans, and generally have accurate plans available of any space for which a perspective is to be drawn.

In the basic method described in this chapter, two vanishing points are used to generate the kind of perspective most often seen, that is, a "two-point" layout. The "one-point" perspective is, in reality, a special case of revolved plan two-point perspective in which the second vanishing point has moved outward to infinity, leaving only one vanishing point on the drawing board. This situation results in certain simplifications, and, for that reason, students are often taught to make one-point perspectives as their first step in developing perspective drawing technique.

Having first learned one-point methodology, however, the beginner often finds it difficult to take on the additional complications of a two-point layout. If two-point technique is mastered from the start, the special case of one-point perspective should not present any problem. The student who learns one-point perspective first is like the automobile driver who has learned in a car with an automatic transmission. It is often a real problem to then learn to drive a car with manual gears. Two-point perspective is not really difficult, and it is actually the most commonly used method. Therefore, it is offered here as a basic first step. Discussion of the one-point special case will follow.

Making a two-point perspective by the revolved plan method requires, naturally enough, a plan of the space to be illustrated. We begin, therefore, with the steps to be taken.

STEP 1

Prepare a scale floor plan of the space to be drawn. A plan will probably already exist as part of the process of design development, or, if an existing space is to be drawn, a design or construction plan can probably be located that will serve. If no plan is on hand, one must be drawn. If an existing plan is cluttered with notes and dimensions (as may be true if it is part of a construction drawing), it may be best to trace or redraw the plan in simplified form, showing only the lines that represent the elements that are to appear in the finished drawing. Walls, openings, and indication of any floor level or ceiling height changes should be shown. Points where materials of floor, walls, or ceiling change should be noted also. Furniture and other secondary elements may be omitted or included as is convenient. Remember that omitted elements can be added to the plan when the time comes to place them in perspective.

The scale of the plan will influence the size of the final drawing, so that it may be advisable to enlarge or reduce an available plan to make it suit the desired size of final layout. A ¼-inch scale (1:50 f.s.) will produce a small layout, unless a very large space is being shown. A ½-inch scale (1:25 f.s.) is often convenient, and an even larger scale can be used for small spaces. If a small-scale plan is used, the resulting small perspective can, of course, be enlarged, but detail may be hard to develop in the small layout.

If a perspective is to be made before any plan has been drawn (as may occur when the designer wishes to explore design concepts in rough perspective sketches), a rough sketch plan can be drawn and used in the same way that a drafted plan is in the following steps. The plan to be used should be on a sheet of paper not much larger than the plan itself so that it can be moved about easily.

A scale freehand plan including details (furniture and rug) that will appear in a final perspective.

A drafted, simplified plan
showing only fixed, struc-
tural elements. Such a plan
might be traced from a
working drawing set. The
simplicity of this kind of
plan can be helpful in be-
ginning perspective con-
struction.

STEP 2

It is now necessary to make key decisions that will govern the final drawing. These decisions are: (1) where to stand, and (2) the direction in which to look. When viewing a real space, the viewer can use movements of the eyes and head to change the angle of view and in this way can build up a mental image that cannot actually be seen from a fixed-eye viewing point. The designer making a perspective does not have this option. A drawing must assume a fixed position and angle of view.

At the drawing board, study the plan and decide where to "stand" so as to include the angle of view desired. If only one perspective is to be drawn, this will usually be a point where the most interesting and attractive features of the space will be in view. Mark the point chosen and circle the point so that it will be easy to locate. The usual designation is *station point*, so that the abbreviation SP may be used as a marker.

Now decide on the direction in which you plan to look and indicate this direction by placing a short arrow with its end at the station point. The direction of this arrow determines what will be at the center of the completed drawing and influences what can be included. Now rotate the plan with station point and arrow in place until the arrow is vertical (pointing straight upward) on the board. This process of rotation gives to this method of perspective its name, "revolved plan method."

In practice, it is usually best to experiment a bit before making a firm decision about locating the station point and determining the angle of view. One can include in an angle of view the cone of vision that will appear in the plan as an angle of about 60° (30° on each side of the viewing direction arrow) without introducing distortion at the edges of the drawing. A wider angle, up to about 90° (45° on either side of the arrow) is often possible and desirable, even though some distortion may appear in the resulting drawing.

In choosing station point and angle of view, it is often helpful to prepare a separate tracing sheet on which are drawn a station point, viewing direction arrow, and dotted lines to indicate the limits of the 60° and 90° viewing angles. Sliding this sheet about over the plan gives the designer an idea of how various station point locations will work out and what elements will be visible within the cone of vision. The station point can be moved outside the space to give a view through a window or door, or it can even be placed outside a solid wall creating a view that could never be seen in actuality. Such "cheating" is often advisable, particularly when drawing small spaces in which an actual viewer must turn to right and left to build up a full mental image.

Once the station point has been positioned and the angle of view selected, the plan can be taped down with the station point and angle of view arrow in place, making sure that the arrow is vertical. If the angle of view chosen places the arrow parallel to the side walls of the space, a one-point perspective will result, as discussed in Chapter Two. To generate the two-point perspective under discussion here, the plan must be at an angle, preferably not a 45° angle nor a very slight angle for reasons that will become clear later. The angle that suggests the most promising view will usually turn out to be quite satisfactory.

When taping the plan down, position it on the board to leave room for the actual perspective in a convenient location—this may be either above or below the plan. If the plan is placed high up, the perspective developed below it will be more convenient to work on. On the other hand, construction lines will be carried across the plan as work goes on in a way that can become confusing. In the illustrations that follow, the perspective is developed below a plan, but identical results would be achieved if the plan had been located below and the perspective developed above it.

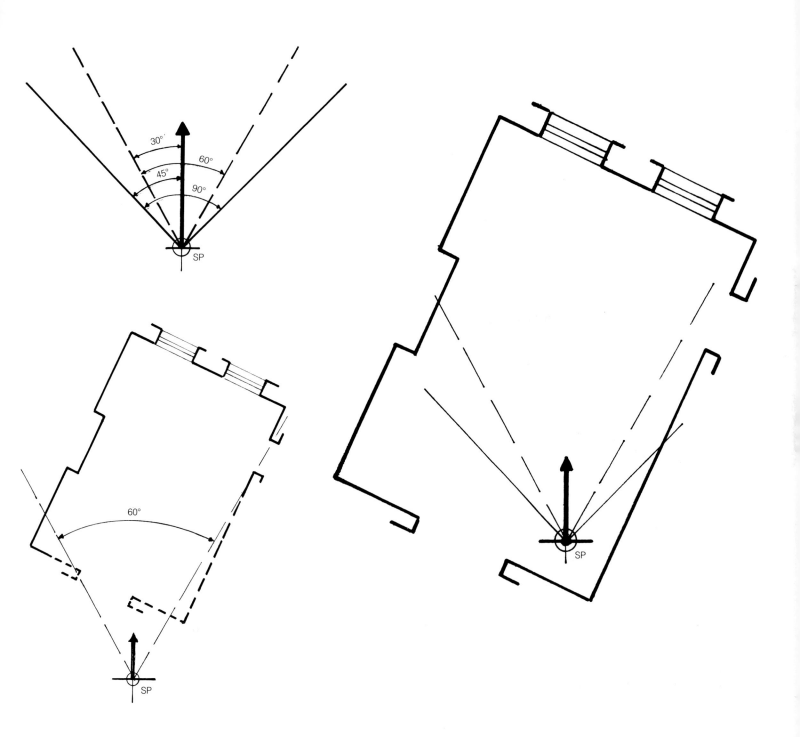

STEP 3

Draw a horizontal line across the plan through the farthest corner of the plan. This line is the plan projection of the *picture plane*, the imaginary surface on which the drawing will be projected. It is a key element in the construction of the view. A picture plane can be positioned differently, through a near corner of the space, or even entirely outside the plan to the rear of the space shown. Reasons for such alternative choices will be discussed later. At this point, the far corner of the plan is the best location for the picture plane.

PP
Picture plane

Picture plane (PP) located to pass through the rear corner of the space. Dotted alternative locations could be selected such as the near corner of space, or an arbitrary location farther back.

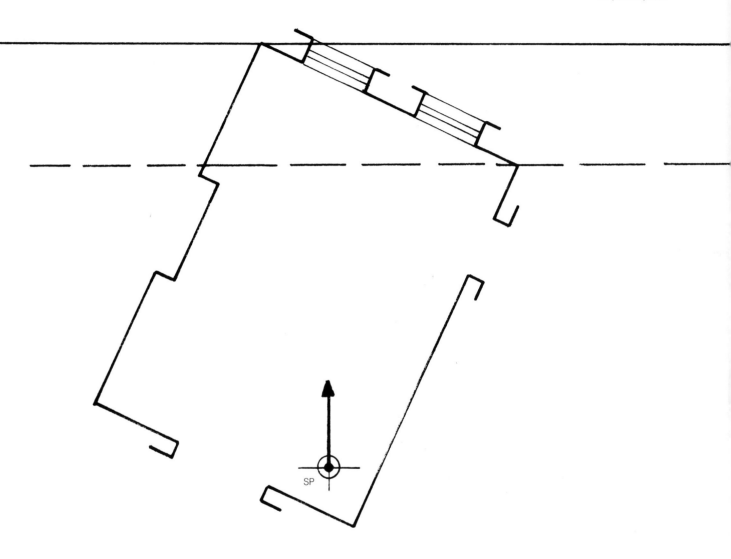

Alternate locations
for picture plane

SP

STEP 4

Assuming that the space being drawn is rectangular or square (irregular shapes are a special case to be discussed later), its walls will appear in the plan as two sets of parallel lines—one set representing front and back walls, the other set the two side walls. Other elements in the plan are likely to be shown with lines parallel to one or the other of these main, axial systems of lines.

For each such system, a *vanishing point* is required. Normally, this will mean two such points, one to the right and one to the left. To locate the plan projections of the vanishing points, draw a light construction line through the station point parallel to first one and then the other main system of parallels, extending these construction lines until they reach the plan projection of the picture plane (the horizontal line drawn in Step 3). Mark these intersections and label them VPL and VPR for vanishing point left and right.

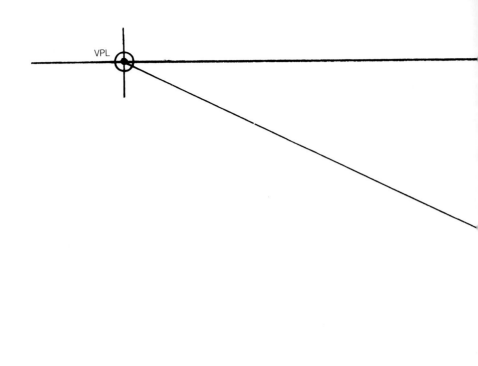

Construction lines parallel to each pair of walls are extended to the picture plane to locate vanishing points at left (VPL) and right (VPR) in plan.

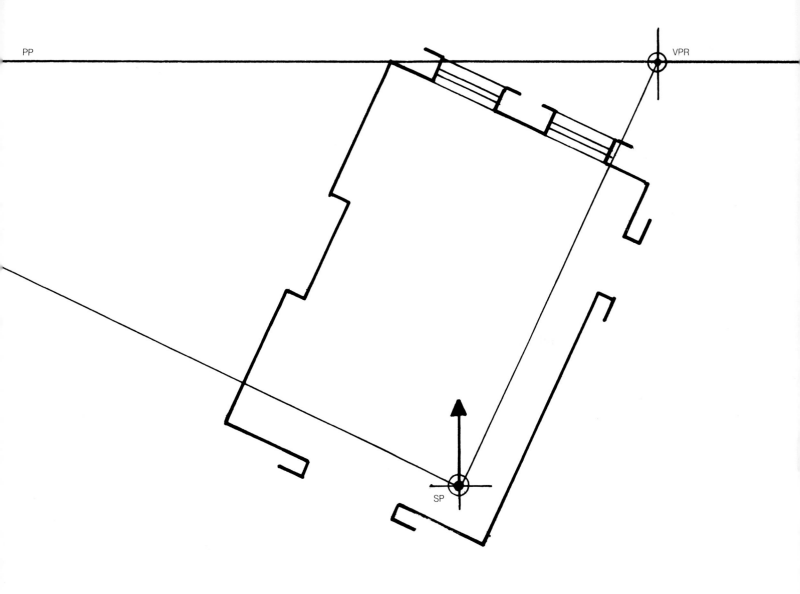

PP

VPR

SP

STEP 5

It is now possible to start the actual perspective. At what seems to be about the center (between top and bottom) of the drawing to be made, draw a horizontal line right across the sheet, at least as far as the locations of the vanishing points in plan. This is the *horizon* of the final drawing. In an exterior view, it would actually be the horizon where earth (or sea) meets sky. In an interior, the actual horizon will usually not be visible (unless it appears through a window), but it is a key construction line because the vanishing points lie on it. To locate the vanishing points, simply drop a light vertical line from the plan projections of the vanishing points (as located in Step 4) to the horizon. Mark these intersections VPL and VPR also. They are the most important controls in making the final drawing.

If the plan has been rotated only slightly so that one set of lines in it is close to horizontal, it will be found in Steps 4 and 5 that one vanishing point is very far away; it may even be entirely off the drawing board. Dealing with this situation will be discussed later, but for the moment, if this situation should develop, simply rotate the plan further until both vanishing points can be conveniently marked on the drawing, or at least somewhere on the drawing board. It may be helpful to insert a pin in each vanishing point.

A horizon line is drawn and construction lines are dropped to locate the vanishing points for the perspective drawing itself.

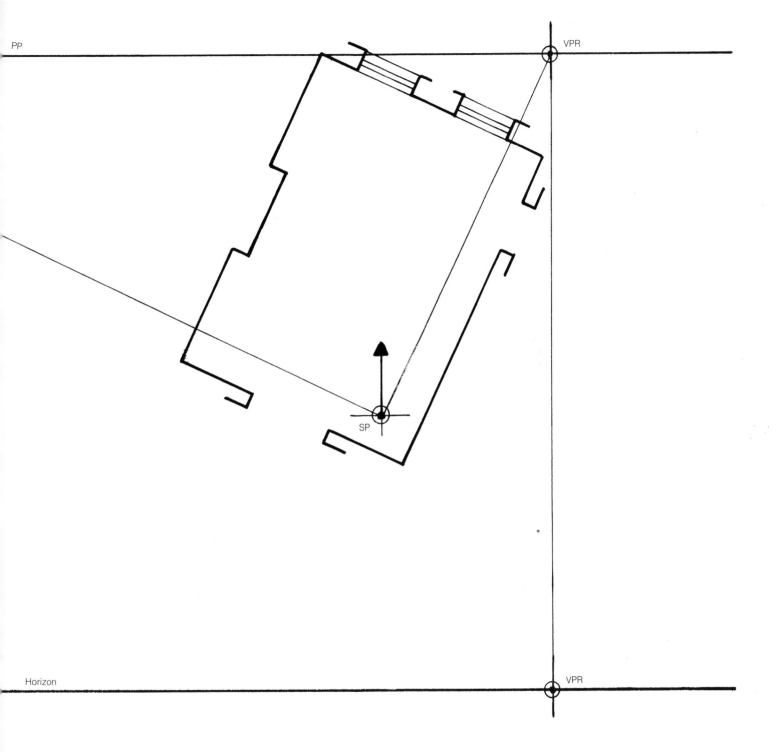

PP

VPR

Horizon

VPR

SP

STEP 6

From the point where the backmost corner of the plan touches the plan projection of the picture plane, bring down a light vertical line across the horizon line. This will become the *height line*, another key element in the constructed perspective. Decide on the eye level that will be used for the drawing. Normally this is 5 feet (1.52 m) or 5 feet 6 inches (1.67 m) above floor level. A lower or higher eye level may also be chosen according to the effect desired.

Measure downward from the horizon along the height line using the same scale as that to which the plan is drawn. Mark the low point clearly. Now measure upward from the low point the total height of the space (again at the same scale as the plan) to a high point above the horizon. Mark the high point and draw in the resulting vertical line clearly. This line represents the far corner of the space being drawn and is the only place where true heights can be measured to scale.

A height line is located by drawing a construction line dropped from the rear corner of the space in plan. It extends below the horizon a scale of 5 feet (1.52 m) to establish a normal eye level. Its total height is the scale ceiling height of the space.

26

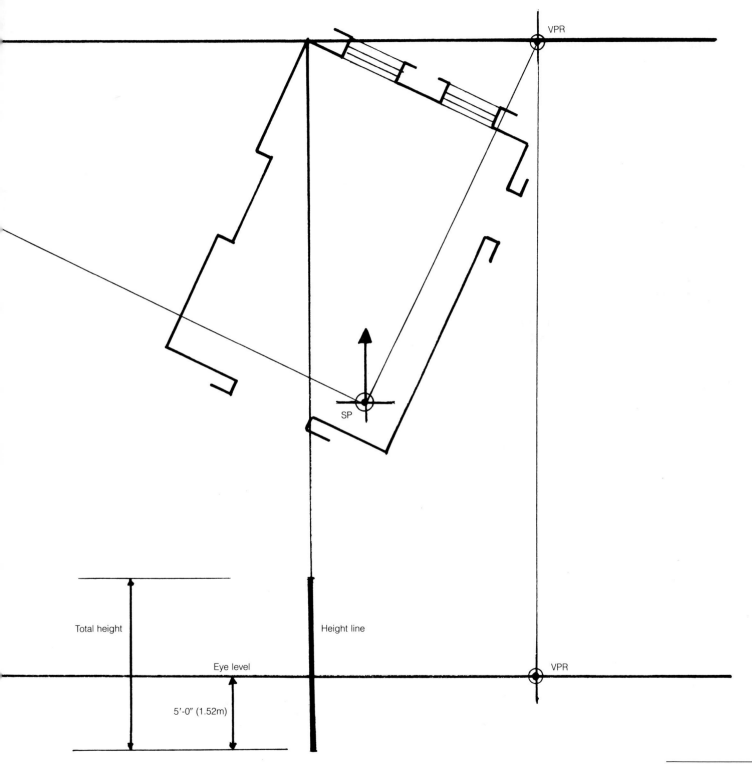

VPR

VPR

SP

Total height

Height line

Eye level

5'-0" (1.52m)

STEP 7

It is now possible to draw lines outward from each vanishing point through the top and bottom ends of the height line. These are lines that represent the top and bottom edges of the space being drawn—the intersections of floor and ceiling planes with walls. From the left vanishing point, these lines will extend to the right of the height line, from the right vanishing point, to the left. A skeleton image now appears, showing floor, ceiling, and two adjacent walls of the space.

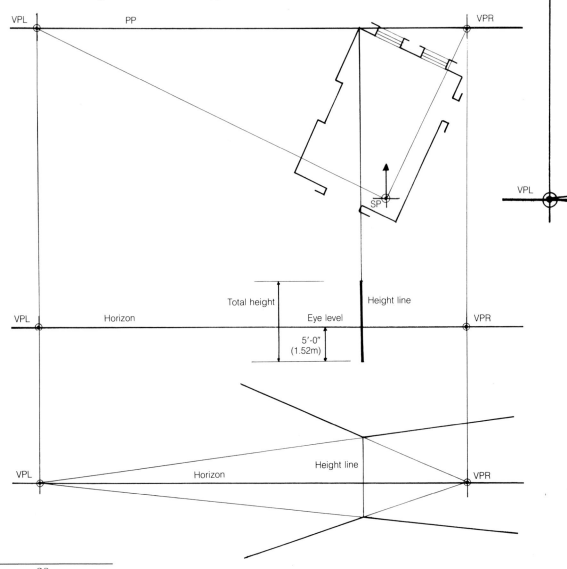

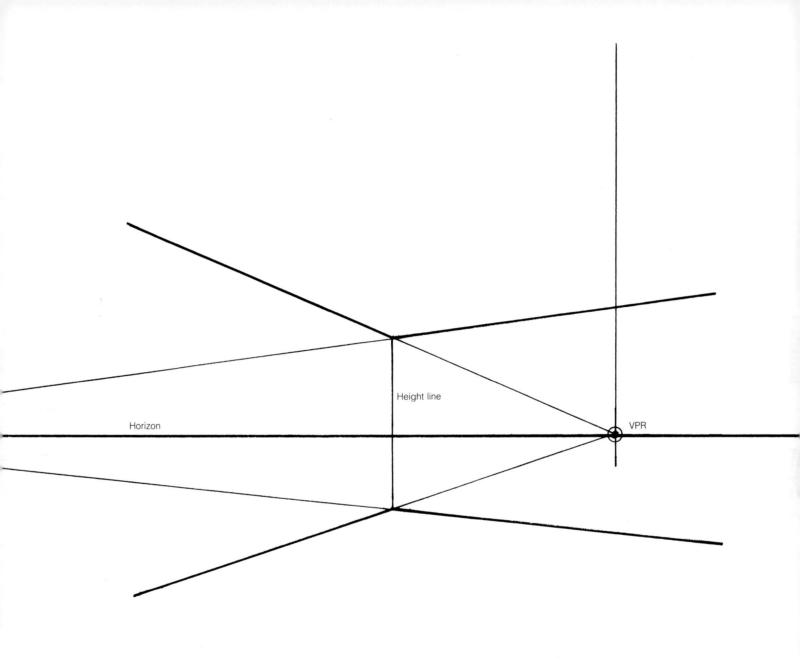

Height line

Horizon

VPR

Lines radiating from the two vanishing points and passing through top and bottom of the height line begin to define the perspective space.

STEP 8

It is now possible, if it falls within the *cone of vision*, to locate a second corner of the space being represented. To do this, draw a light construction line (sometimes called a *sight line* or *ray*) on the plan from the station point through the second corner onward to the picture plane. Drop a vertical construction line from this intersection down across the horizon. The part of this vertical which extends from the upper to the lower ceiling and floor corner lines becomes the second visible corner of the space. From its top and bottom, additional lines radiating from the appropriate vanishing point will define another "wall" of the space represented, creating the effect of a "box" viewed from within. This gives the sense of a room or similar interior space.

The right-hand corner of the room is located with a construction line in plan. Once this is drawn into the perspective, it permits drawing in of the right-hand wall.

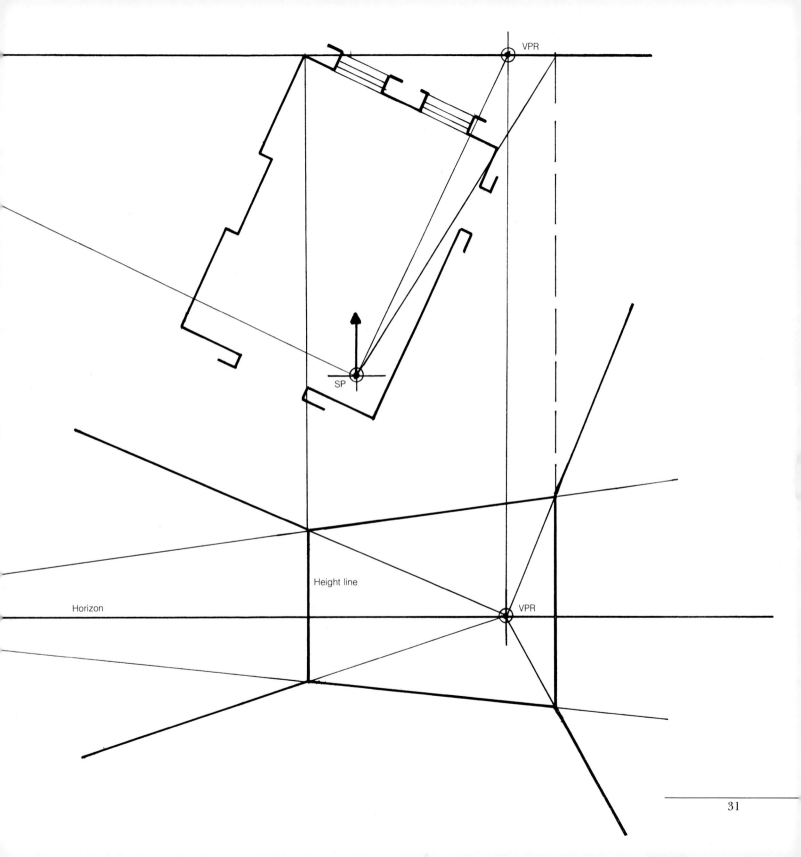

VPR

SP

Height line

Horizon

VPR

STEP 9

To locate forms such as windows or doors on the walls of the represented space, draw additional sight lines from the station point in plan through the edges of these elements as they appear in the revolved plan onward to the picture plane. Drop vertical construction lines down across the perspective to establish the locations of left- and right-hand edges of these elements.

VPL

VPL Horizon

Locations of edges of windows, door, chimney breast, etc., are established with additional construction lines.

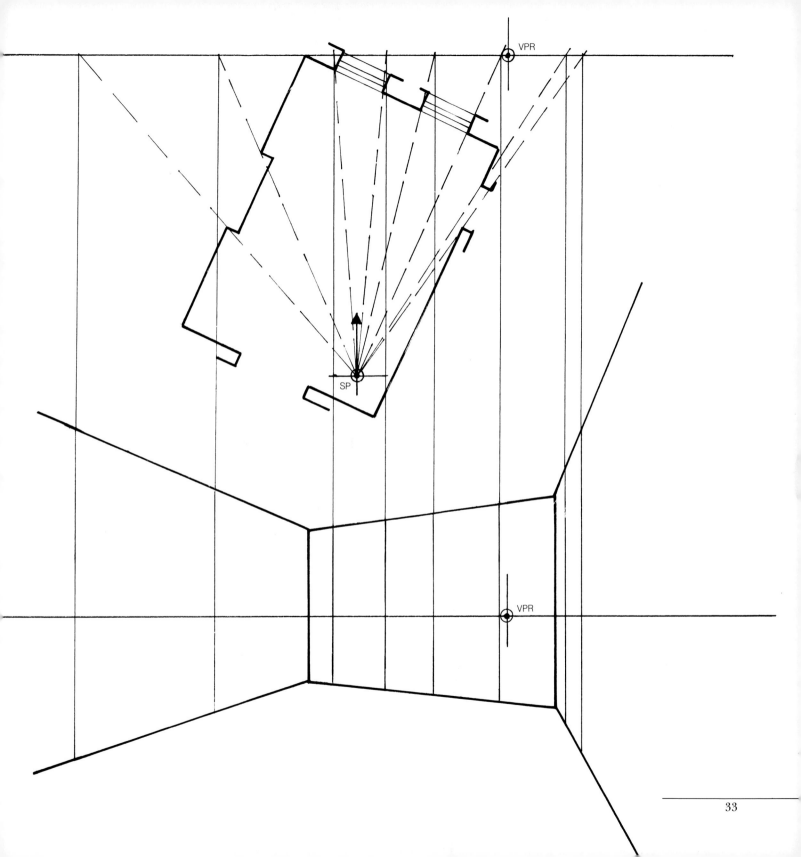

SP

VPR

VPR

STEP 10

To establish heights (top and bottom lines) of elements on the walls, measure upward from the floor along the height line (backmost corner) using the same scale used for the plan drawing. A window, for example, will have a sill line up from the floor by a known height, and a head at a known height. A door will have a top line at its correct height from the floor. Mark these heights on the height line and then bring light construction lines outward from the appropriate vanishing point until they pass across the verticals representing sides of the openings in question. Now draw in the four sides of each such form heavily. Divisions within these forms (for example, window sash panes or door panels) are found in the same way as the edges. Other elements along the walls, such as changes of materials, fireplaces, shelves, pictures, or mirrors, are found in the same way.

Heights can be located on the height line by measurement (as suggested previously) or can be transferred graphically from an elevation drawing. The latter technique may be convenient if many height dimensions will be required. In order to do this, an elevation (or several elevations) drawn to the same scale as the plan must be available. As with the plan, it will be convenient to have a simplified elevation on a separate sheet of paper trimmed so as to be slightly larger than the elevation itself. Tape the elevation down to the right or left of the perspective. Make sure that the horizontals are accurately parallel with the horizon line and that the floor line is lined up horizontally with the bottom of the height line. Heights can now be carried horizontally to the height line with light construction lines instead of using scaled measurements.

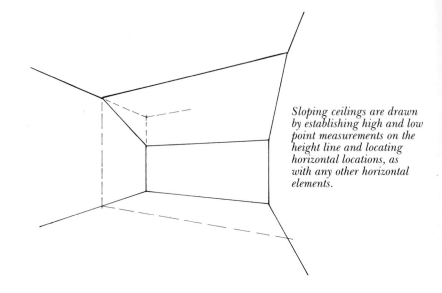

Sloping ceilings are drawn by establishing high and low point measurements on the height line and locating horizontal locations, as with any other horizontal elements.

VPL

Elevation on separate sheet

Elevation on a separate sheet can be moved into position to make transfer of heights to the height line convenient. Tops and bottoms of openings can now be drawn in.

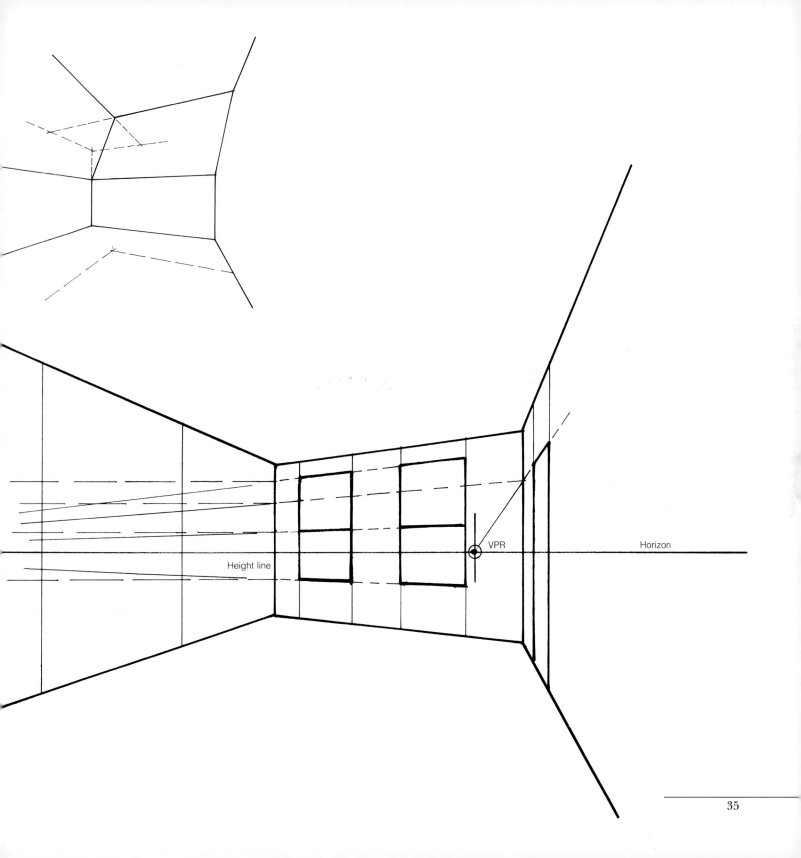

Height line

VPR

Horizon

35

STEP 11

Objects adjacent to walls, such as pieces of furniture, counters, or shelves, can be constructed by first drawing in lightly the back of the object against the wall, locating it, and establishing height as described in Steps 9 and 10. Lines are now brought outward from the appropriate vanishing point along the floor. A front corner can be located by drawing a sight line in plan from the station point, through the corner in plan, and then back to the picture plane. Dropping another light construction line from this point vertically down into the perspective until it intersects with the appropriate line on the floor locates this corner. Lines can now be added to form the complete "box" representing the object in question. Front, visible edges are drawn in heavily while the hidden lines representing back and bottom edges that cannot be seen are erased (or left lightly visible for future reference).

Construction lines create a "box" to enclose objects against a wall or to define the form of the fireplace opening.

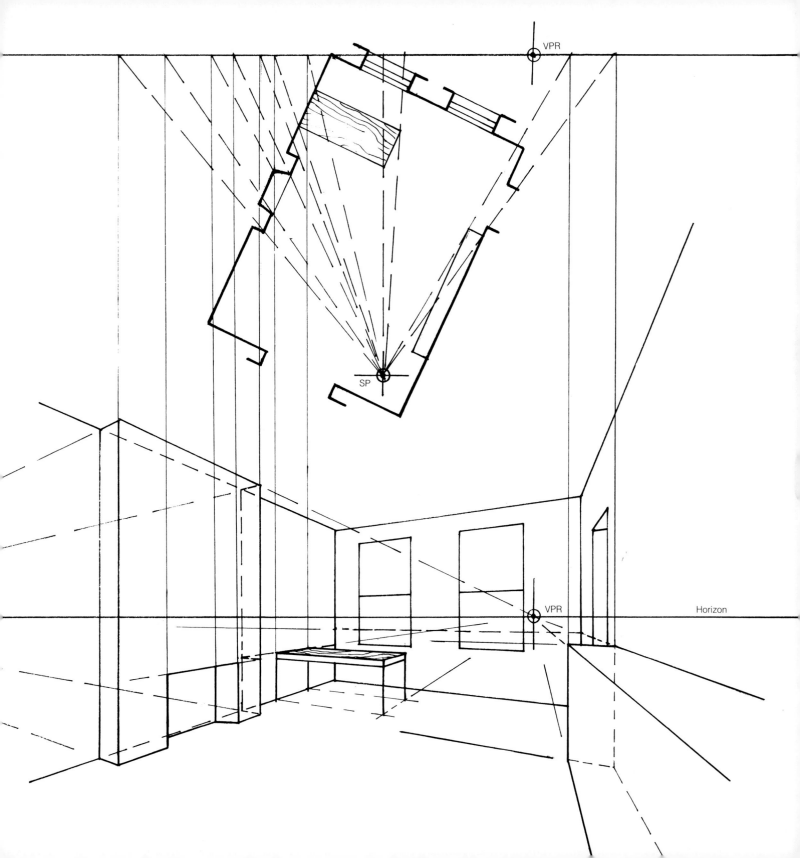

VPR

SP

VPR

Horizon

STEP 12

To locate a free-standing object within the space (such as a piece of furniture), draw the object in place in the plan. An object placed so that its lines are parallel to the walls of the space can then be drawn as described in this step. If the object is placed at an angle to the walls, the process is somewhat more complex, as described in Step 13.

For objects that are parallel to the walls, draw a light sight line in plan from the station point, back through the visible (three front) corners of the object, and back to the picture plane. Draw a light construction line from any one of the visible corners parallel to one set of walls until it reaches a wall. This can be thought of as a "chalk line" marked on the floor, which will now be put into perspective. Locate the point where this line meets the wall by taking a sight line back to the picture plane (from the station point through the intersection of the chalk line with the wall), then drop a light vertical from that intersection across the perspective until it reaches the bottom edge of the wall. Through this point, bring a line out from the appropriate vanishing point, drawing it lightly to represent the chalk line in perspective.

The corner of the object on this line can now be located by dropping another construction line from the intersection of the sight line passing through this corner with the picture plane. With one corner located, the plan of the object in perspective can be developed with lines coming from the vanishing points and extended to the other corners found in the same way as the first corner. Once three corners are located, finding the fourth corner will be automatic.

Height is established by measuring up from the floor along the height line and bringing this height along one wall and outward into the space with a line parallel in perspective with the floor-level chalk line. Be sure to use the appropriate vanishing point for each line. Irregularly shaped objects (a curved chair or sofa, for example) are placed by constructing a box of imaginary lines containing the form and then drawing the appropriate curves or shapes within this box.

VPL

Free-standing furniture is located with additional construction lines.

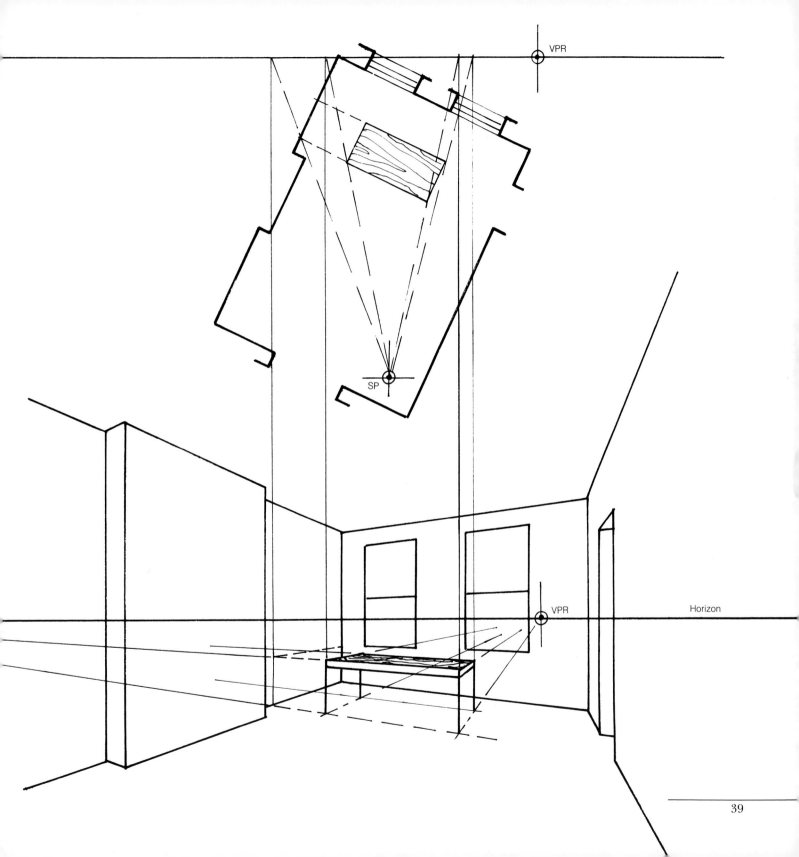

VPR

SP

VPR

Horizon

39

STEP 13

Free-standing objects that are placed at an angle with the walls of the space can be located in several ways. Each corner of the object in the plan can be located in the perspective with imagined chalk lines as described earlier. When the corners are connected, a plan of the object in perspective will result. It will be found that each pair of sides of this object plan are converging toward new vanishing points on the horizon. It is convenient to mark and use these vanishing points while the object is being drawn. Height is now established for one corner, as described in Step 12. The new vanishing points are then used to complete the "box," which represents the object or encloses it if it is curved or irregular in form.

An alternative way of finding these auxiliary vanishing points is to revert to the method described in Steps 4 and 5. Treat the object in question as if it alone were to be drawn in perspective and locate vanishing points for it by running construction lines in the plan through the station point to the picture plane parallel to its edges. Drop verticals to the horizon in perspective, and use these intersections as the special-purpose vanishing points. It is an interesting exercise to try to lay out the perspective of an object by first one and then the other of these two methods. Identical results will be produced if the drafting is accurate.

It is often helpful to use an overlay sheet of tracing paper for the development of the perspectives of individual objects present in a space. This keeps the basic drawing uncluttered with construction lines and makes it possible to try out different locations for movable objects. The auxiliary sheet itself will be a complete perspective of the object being drawn, but it will fit in with the basic perspective drawing being developed. When the drawing of the free-standing object is satisfactory, it is traced onto the basic drawing. Use reference points (such as two X marks) to make sure that the auxiliary drawing is placed correctly when it is moved from on top of to underneath the main drawing.

Furniture at an angle to the walls can be located in two ways: either by locating each corner, or by locating one corner and using auxiliary vanishing points (AVPL and AVPR). Both methods produce the same results.

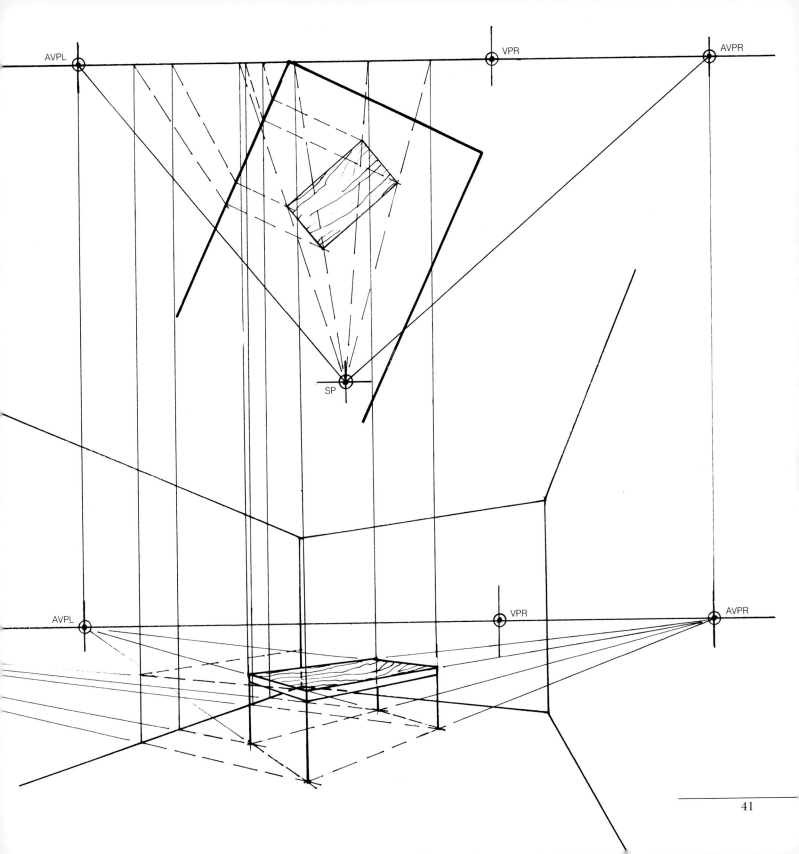

SP

AVPL VPR AVPR

41

STEP 14

It is useful to draw new vanishing points at any time that elements of a space are set at an angle with the main systems of walls. Angled walls or stairs, a partly opened door, an angled rug or floor pattern can all be dealt with most conveniently by setting up new vanishing points. Keeping the work done with extra vanishing points on an extra sheet, as described previously, is often convenient.

When spaces are not rectangular, but of some special shape or irregular in plan, use of an additional vanishing point for each system of parallels is the most effective way to deal with the problem. A hexagonal space, for example, requires three vanishing points, one for each of the three systems of parallel walls. Spaces that are round or otherwise curved in plan present problems that are dealt with in some detail in Chapter Two.

Various elements at angles can be dealt with by establishing additional auxiliary vanishing points. Here, AVPRL and AVPRR are used for the rug, AVPC for the chimney breast, AVPD for the open door. The corridor extends back behind the picture plane.

VPL

VPL Horizon

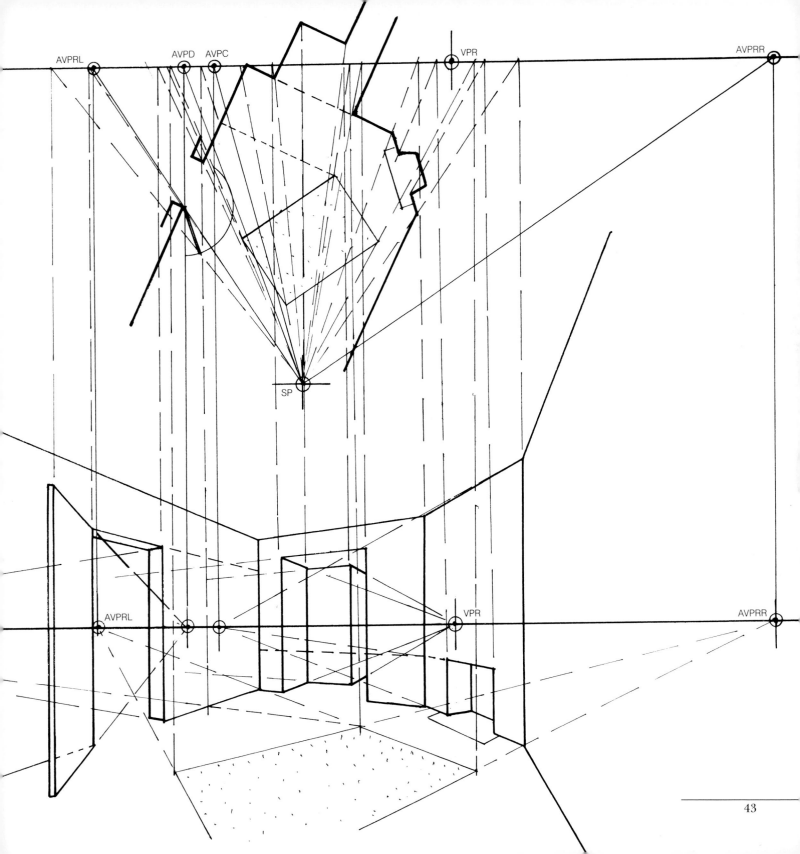

AVPRL AVPD AVPC VPR AVPRR

SP

AVPRL VPR AVPRR

ADDED SUGGESTIONS

Notice that the "back wall" described in this chapter need not be the backmost element in the perspective view. Spaces may be drawn extending back from it, even extending behind the picture plane. This is routine when showing alcoves or bays in the back wall, but it also can deal with deeper space: an adjacent room seen through an opening or a corridor extending into the distance. Heights are determined from the height line as for any other element—lines are carried back toward the appropriate vanishing point and distant corners are located with sight lines that are brought *forward* (instead of backward) to intersect the picture plane.

The picture plane can be placed as near or as far back as desired, but it is convenient to have it pass through a corner that will serve as a height line for two major wall planes.

Some spaces may be confusing to draw in perspective because they lack the box-like character of the typical room used in the illustrations provided here. The "open space" that is characteristic of much of modern architecture, including lofts and exhibition spaces, is often difficult to put in perspective.

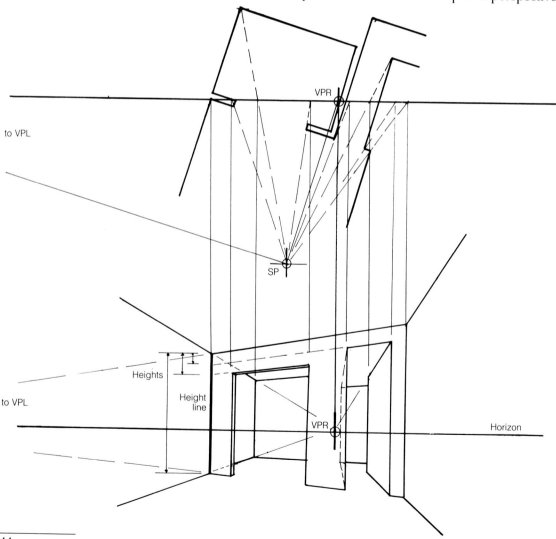

Spaces extending behind the picture plane with heights measured (to scale) at the height line.

To represent a totally open space would actually require nothing but blank paper (or perhaps just one horizon line). However, all real spaces have elements which, as they are placed in perspective, generate the illusion of real space. In open spaces, these elements may be columns, patterns of floor and/or ceiling materials, screen walls, furniture elements, or some combination of such features, all of which can be constructed in perspective.

It is often helpful to create "imaginary walls" marked out in plan and set up just as a room interior is set up in perspective. Column locations or other modular elements of an architectural plan are useful, along with imagined planes, in setting up a space envelope in which to locate whatever elements are to be visible in the space. Imagining chalk lines on the floor and ceiling with a plumb line vertical connecting them will serve as a starting point, however abstract, to get an "open space" view under way. Once a reference plane or two have been established, other parts of the drawing will develop logically in either the two-point perspective discussed in this chapter, or in the one-point perspective described in Chapter Two.

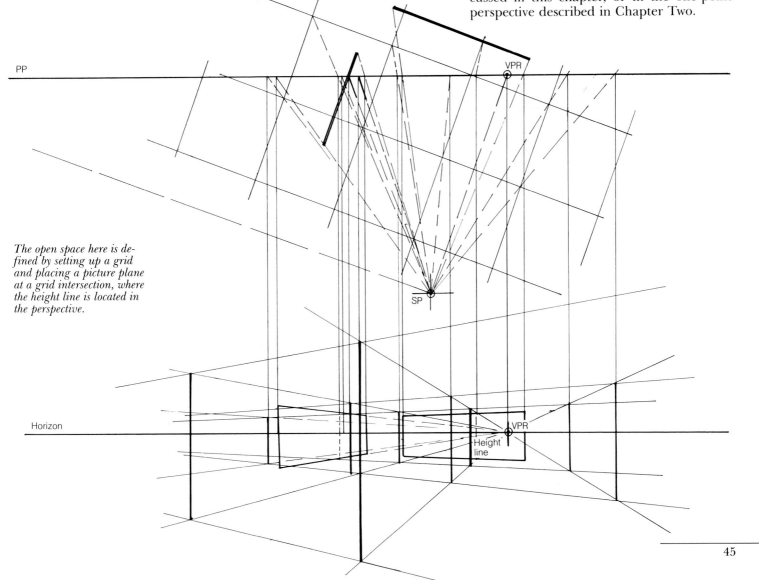

The open space here is defined by setting up a grid and placing a picture plane at a grid intersection, where the height line is located in the perspective.

PP

SP

VPR

Horizon

VPR

Height line

45

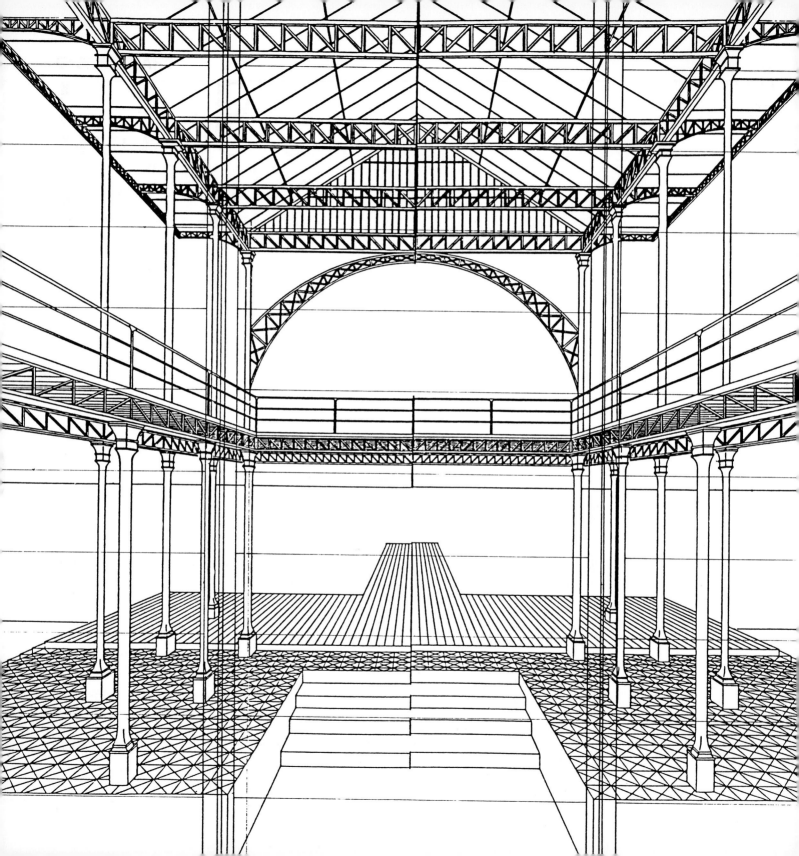

An example of one-point perspective. A fantasy "glass-house" space designed and drawn by Jean-Pierre Heim.

Special Situations

K EEPING THE BASIC techniques for drawing two-point perspectives of simple geometric spaces in mind, it is possible to move on to examine several situations that call for modification or elaboration of the basic method. In general, these are simply variations on the techniques described in Chapter One. Some, however, may seem to be quite puzzling until they are reviewed in detail and tried out in practice.

One-point perspective is probably the most commonly used and important modification of the basic technique. Although it is actually only a special case of two-point method, it merits a full, step-by-step exploration. Drawing circles, parts of circles, and other curved forms involve some special problems and may confront the draftsman with choosing between drawing what is geometrically accurate and what will *appear* true to life, even if it is not actually theoretically precise.

Placing furniture in perspective, dealing with reflections, shadows, and other effects of light, and drawing views of interior space taken from above all follow the basic methods discussed. These can seem to be difficult to do until actually worked out on paper. Views looking sharply upward or downward can call for the use of three-point perspective, a technique that will be discussed here briefly. Finally, some shortcuts that can ease the chores of geometric layout are reviewed.

ONE-POINT PERSPECTIVES

The most frequently encountered and most useful of "special-case" perspective construction is the one-point view, so called because only one vanishing point is available for use. This results in some simplifications that may make it seem easier than two-point perspective. For this reason, one-point perspective is often taught as a first step in learning perspective. However, viewing one-point construction as a special case of the general two-point, revolved plan method, leads to a better understanding of both methods and makes it easy to select the approach best suited to any situation.

A one-point perspective will result whenever the plan used as a basis for the drawing is placed with its main systems of lines horizontal and vertical—that is, when the "revolved plan" is *not* revolved, but placed in its usual T-square and triangle orientation. When the picture plane is placed along the rear wall of the space, true heights and widths can be measured anywhere on this back wall as it appears in perspective. In other words, the perspective representation of the back wall turns out to be a true elevation.

After the station point is positioned in the plan, one vanishing point will fall somewhere near the center of the perspective, while the other vanishing point (or points, since there would be, theoretically, one at right and one at left) cannot be used; it will be moved to a location infinitely far away to the right or left. This makes all lines on one system of parallels true horizontals that can be drawn with a T-square, while the lines in the other system of parallels all are drawn radiating from the one vanishing point. The steps in making a one-point perspective closely follow those used in making a two-point drawing. They are summarized here with the details already discussed for two-point perspectives either omitted or simplified.

STEP 1

Obtain a scale floor plan of the space to be drawn. Locate the station point on the plan. The direction in which to look must be parallel with one system of walls, that is, "straight up" as the plan is placed on the drawing board. If the station point is placed exactly at the center of the space, the resulting drawing will be symmetrical and will tend to emphasize formality and dignity. When a symmetrical space is being illustrated, the resulting drawing will itself be totally symmetrical. For monumental and formal spaces—such as churches, courtrooms, and many rooms of traditional design—this emphasis on formality may be desirable.

If the station point is placed to the right or left of center, a more informal and "natural" view will result with whatever is seen straight ahead from the station point falling at the center of the finished drawing. How far back the station point is placed will determine how wide a field of view can be included without distortion. As discussed in Step 2 of Chapter One, a cone-of-vision diagram showing 60° and 90° viewing angles will be useful in deciding where to place the station point. Once the station point is marked, the plan is taped down, leaving space for the actual perspective to be constructed above or below the plan.

Plan with station point (SP) located in preparation for drawing a one-point perspective. Direction of view is parallel to one system of walls. The 60° and 90° cones of vision indicate what can be included in normal and in wide-angle views.

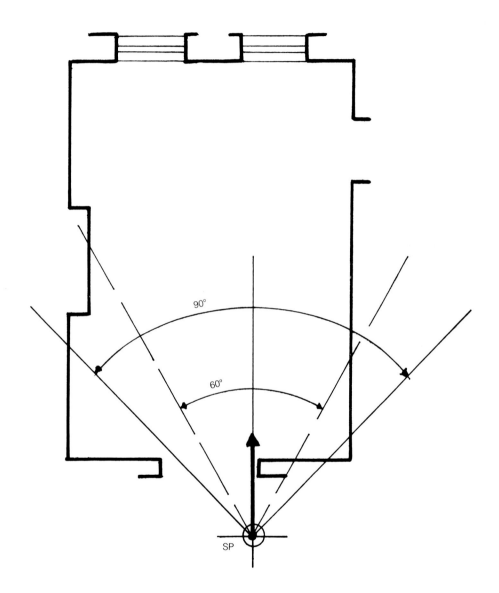

90°

60°

SP

STEP 2

Draw a horizontal line representing the plan projection of the picture plane through the back wall line of the plan.

STEP 3

Draw a light vertical construction line through the station point until it intersects the picture plane (back wall). Mark this intersection VP. An attempt to find a second vanishing point by drawing a horizontal line through the station point will demonstrate why no second vanishing point is used.

The single vanishing point is located in plan by carrying a construction line upward from the station point to the picture plane.

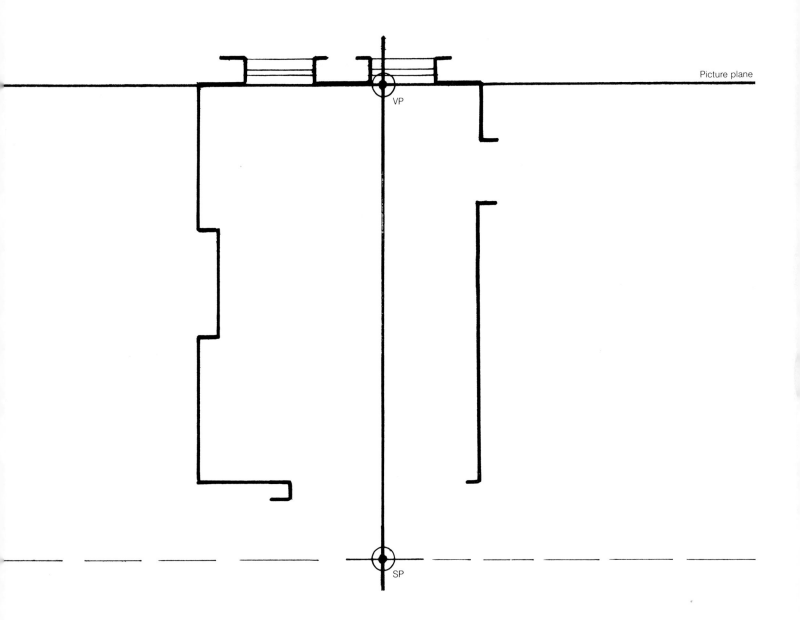

Picture plane

VP

SP

STEP 4

In the area where the actual perspective drawing will be constructed, draw a horizontal horizon line right across the drawing. Drop a light vertical construction line from the plan projection of the vanishing point to the horizon. This intersection is the one vanishing point that will be used. Mark the point VP.

STEP 5

Bring light vertical construction lines down from each rear corner of the plan across the horizon line. Decide on the eye level to be used (as in Step 6 of Chapter One) and measure downward along one corner construction line (at scale) this height—normally about 5 feet 6 inches (1.67 m). Measure the total height of the space upward from this low point. The resulting vertical height line will be duplicated at the other back corner of the space. Horizontal lines can now be drawn to represent the intersections of floor and ceiling with the back wall. The resulting rectangle, which represents the back wall in perspective, will be found to be a true scale elevation in which heights and widths can be measured at any point.

The horizon is drawn and the vanishing point placed on it. A height line permits the development of a back wall with both height and width dimensions drawn to scale.

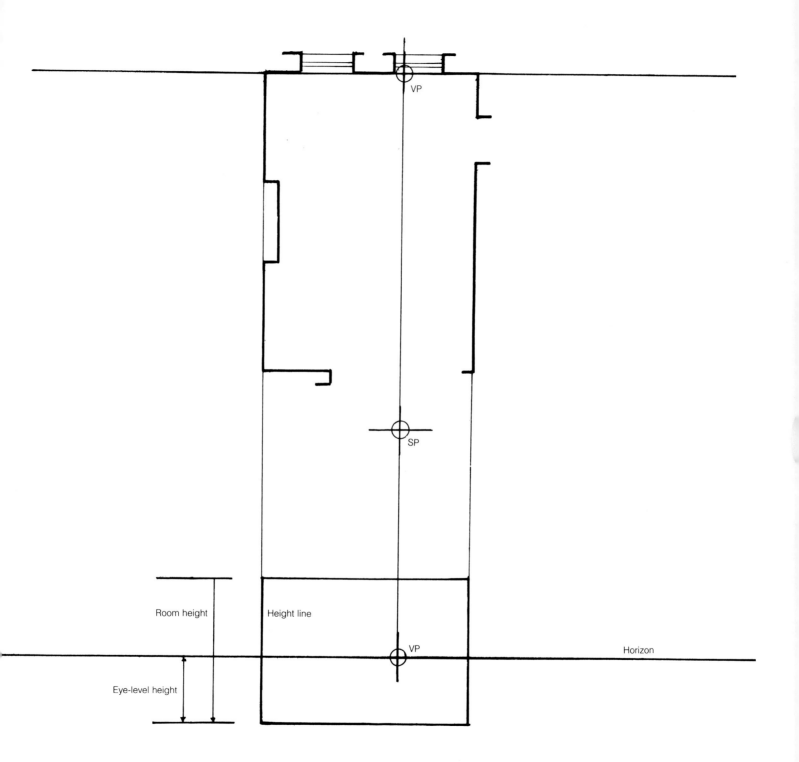

Room height

Height line

Eye-level height

VP

SP

VP

Horizon

STEP 6

Draw lines radiating outward from the one vanishing point through each of the four corners of the back wall. These lines represent the intersections of side walls with floor and ceiling and create the "box" image of the space being represented.

Lines extending from the single vanishing point establish the "room envelope."

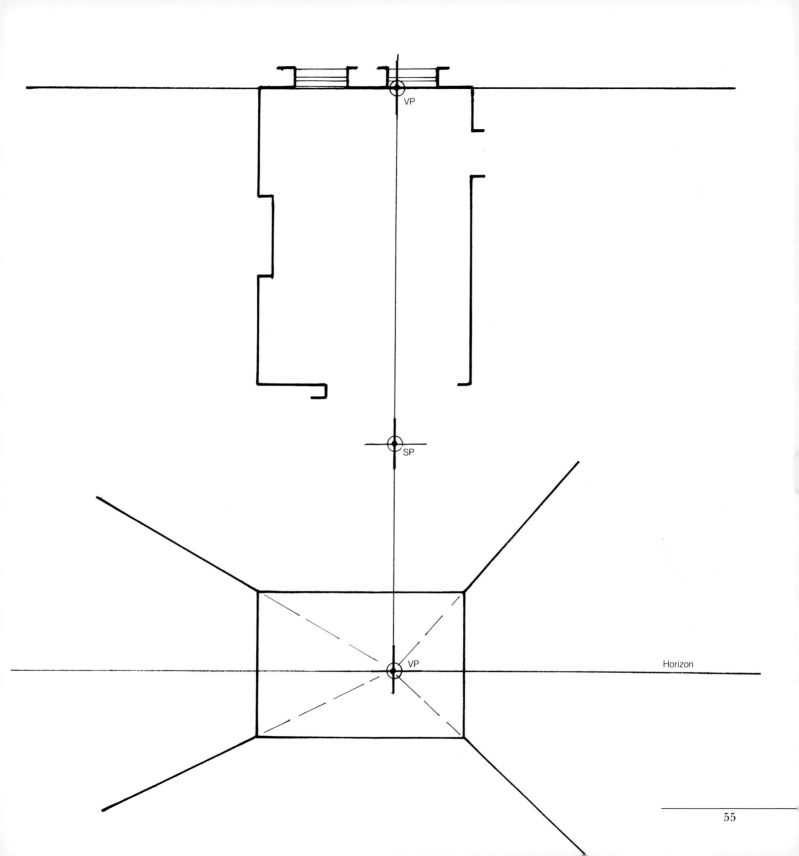

VP

SP

VP

Horizon

STEP 7

Features such as windows or doors in the back wall can be drawn in true scale dimensions or simply transferred from an elevation drawing (if available). To locate elements along either side wall, draw a light construction line in the plan from the station point through the point to be located, extending it onward to the picture plane. Drop a vertical from this intersection across the perspective.

STEP 8

To establish heights of elements along side walls, measure height at either back corner of the space. Bring a light construction line forward from the vanishing point through the measured height until it reaches the construction line, which represents the sides of the element being drawn.

Elements in the back wall are drawn in at scale and heights for side wall elements brought outward from either back corner height line.

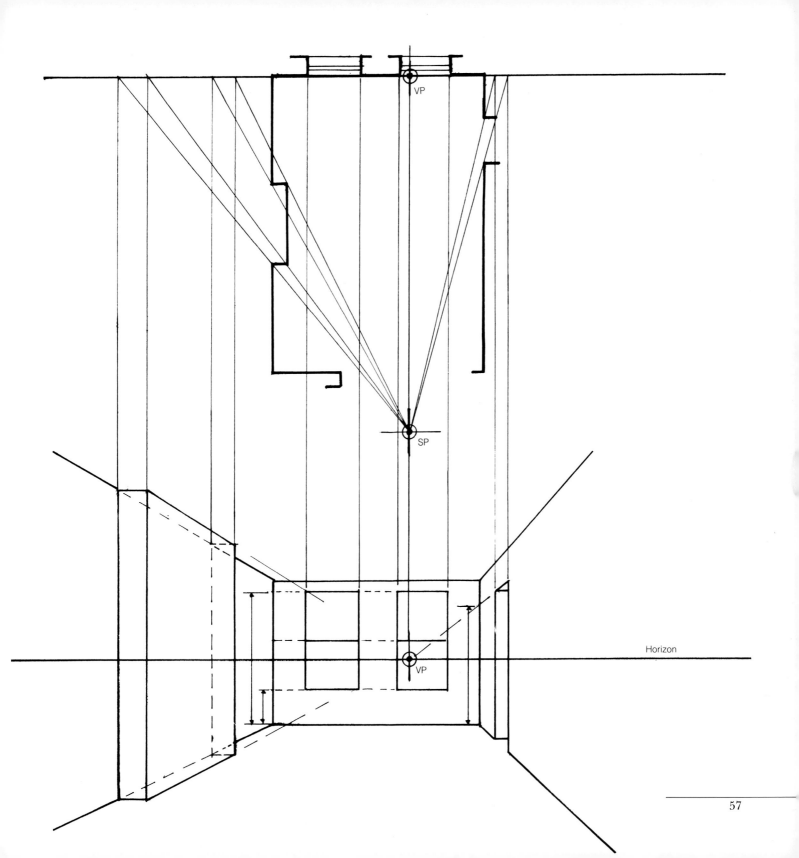

VP

SP

VP

Horizon

STEP 9

Objects adjacent to walls are developed by constructing the back of the object against the wall as described earlier. Lines are now brought out from the wall horizontally to represent edges extended to reach corners that are located with sight lines drawn from the station point back to the picture plane and carried vertically across the perspective.

The remaining steps are comparable to those described in the discussion of two-point perspective (see Chapter One), except that all lines representing lines parallel to the back wall are simply drawn as true horizontals. Objects placed at an angle to the walls can be developed by locating corners as discussed in Step 13 of two-point construction or by finding auxiliary vanishing points as described in that step. In the latter case, the angled object will be drawn in two-point perspective even though it is located within a one-point drawing. In this way, one- and two-point perspective technique can be freely combined in whatever way is found to be most effective.

Objects against side walls are located by construction lines in plan. Edges parallel to back wall are all horizontal. Heights, for cabinet (A) and for table (B), are measured to scale against back wall.

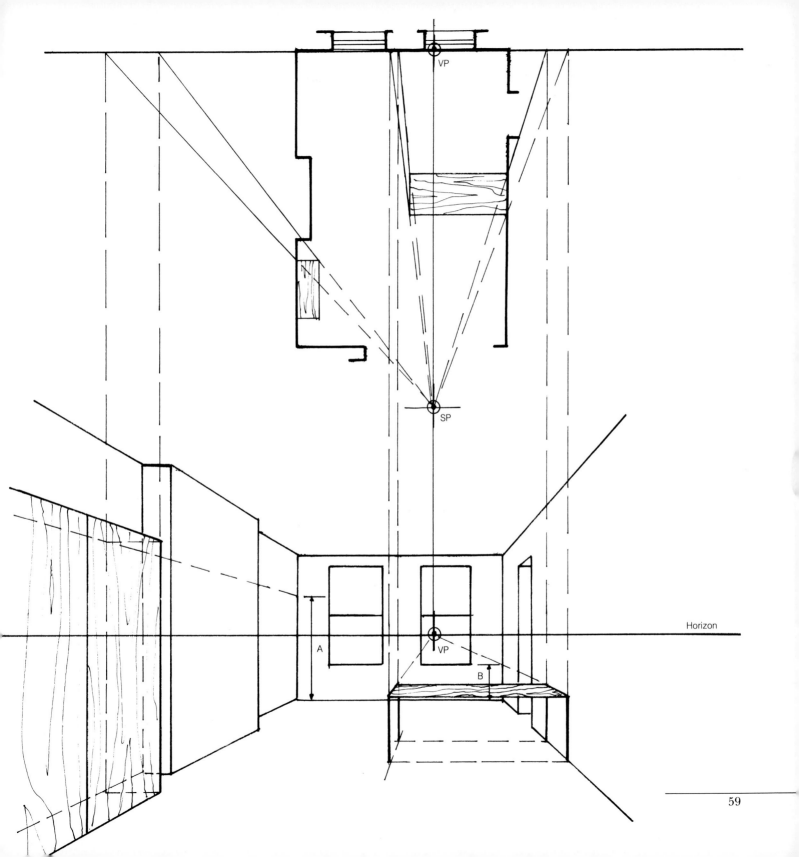

VP

SP

Horizon

A

B

VP

ELEVATION DRAWINGS

It is possible to begin a one-point perspective using an elevation drawing as the primary basis rather than a plan. To do this, a horizontal line is drawn through the elevation at correct eye-level height. A vanishing point is then located on the horizon at the center or somewhat to the right or left of center of the elevation. Lines can then be drawn outward from the vanishing point to represent top and bottom lines of the side walls. In order to place elements that are in front of the back wall accurately, it will still be necessary to use a plan. Place the plan above or below the perspective so that the position of the back wall matches up with the location of the back wall as shown in perspective.

The station point will fall on a vertical dropped down (or brought up) from the vanishing point. How far back to place the station point will depend on what is to be included in the view (as determined by a cone of vision), and this placement will influence the way elements in front of the back wall will appear in the finished drawing. Once the plan and station point have been positioned, elements are located as described in Step 9 of this chapter by drawing construction lines from the station point, through the point to be located, to a picture plane drawn as an extension of the back wall in the plan.

Scale elevation for use as basis for construction of a one-point perspective.

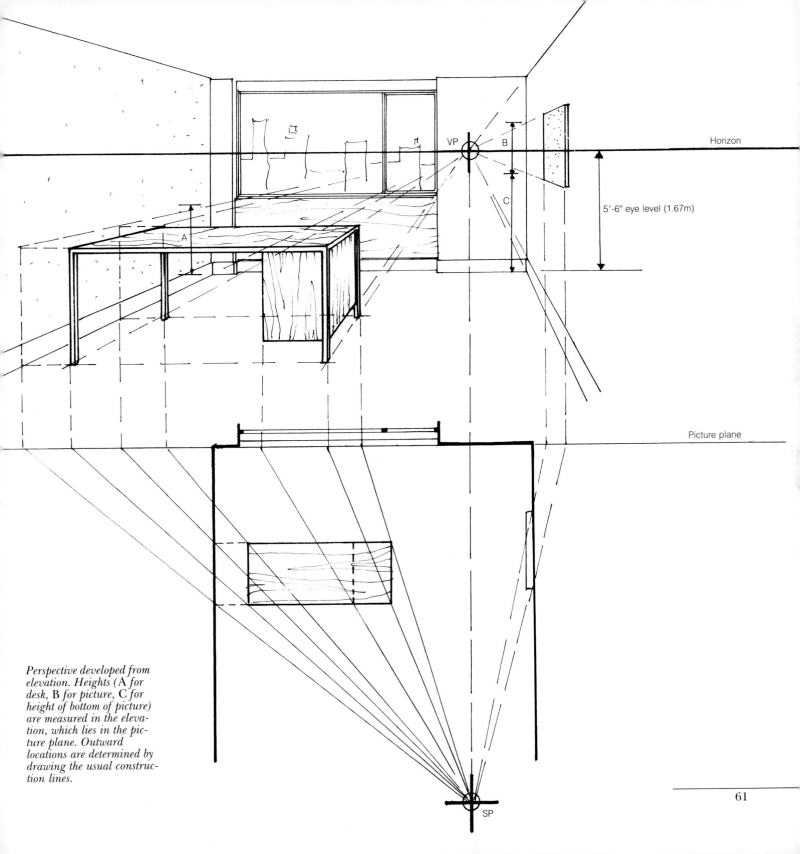

Horizon

VP

B

C

5'-6" eye level (1.67m)

A

Picture plane

Perspective developed from elevation. Heights (A for desk, B for picture, C for height of bottom of picture) are measured in the elevation, which lies in the picture plane. Outward locations are determined by drawing the usual construction lines.

SP

DISTANT VANISHING POINTS

In two-point perspective construction, it will often be found that one (or even both) vanishing points are so far from the center of the drawing as to be inconvenient to use. This will occur most often when the plan is rotated only slightly in relation to the picture plane. A simple solution to the problem is to rotate the plan further until the distant vanishing point moves closer. This may change the resulting view in a way that is not be desirable.

There are several ways to work with a distant vanishing point that are quite practical. One possibility is to find and mark the distant location, even if it is off the board or table. Stretched strings or threads can be used to extend the picture plane, horizon, and construction line off the board to a pin or tack placed on an extra table or other anchorage (a block of wood, even a window sill can serve). Thread is then used to guides key lines moving toward the vanishing point, or one can simply sight along a straightedge toward the VP marker. After a few lines have been placed, other lines can be drawn in by eye with sufficient accuracy.

Another approach is to draw a vertical line at a point half way to the vanishing point. This can be determined by measuring to find the place where the plan construction line has reached half the distance between station point and picture plane. When extended across the perspective, this vertical establishes the point where any perspective line will have moved half way from its starting point to the horizon. A similar line can be set to locate one-third, one-quarter, or any other fractional part of the approach to the vanishing point.

Still another method, which is more precise and convenient to use, but more troublesome to set up, requires locating the distant vanishing point, marking it, and then swinging an arc (with pencil and thread) on the board near its edge with the VP as a center. Two strips of cardboard are then cut to this same arc of curvature so that they fit together along the arc. The strip that is convex toward the drawing is tacked or taped down along the arc. The other strip is attached to a straightedge (which may be another cardboard strip cut to an accurate edge) with the straightedge positioned so that it radiates from the center of the arc. Sliding one cardboard arc along the other will now swing the straightedge so that it will always point toward the vanishing point. Two pins placed along the location of the fixed cardboard strip will also serve as well. Various devices are sold in art supply stores to serve this purpose, but cardboard strips will do the job just as well on the rare occasions when they are needed.

When *both* vanishing points for a two-point perspective are too remote for convenience, it means that the station point has been placed very far from the picture plane. The solution is to move the station point closer to the picture plane, or to use a plan drawn at smaller scale, or both.

A distant vanishing point is placed on an auxiliary work surface using string or thread to control angles of lines.

A dotted line one-half way to the vanishing point is used here to determine where any line will have moved from its starting point, one-half way to the horizon.

This technique depends on the laws of similar triangles that establish $\frac{A}{B} = \frac{C}{D}$.

A cardboard straightedge with an end "head" cut to an arc slides on a fixed strip to provide lines radiating from a distant vanishing point.

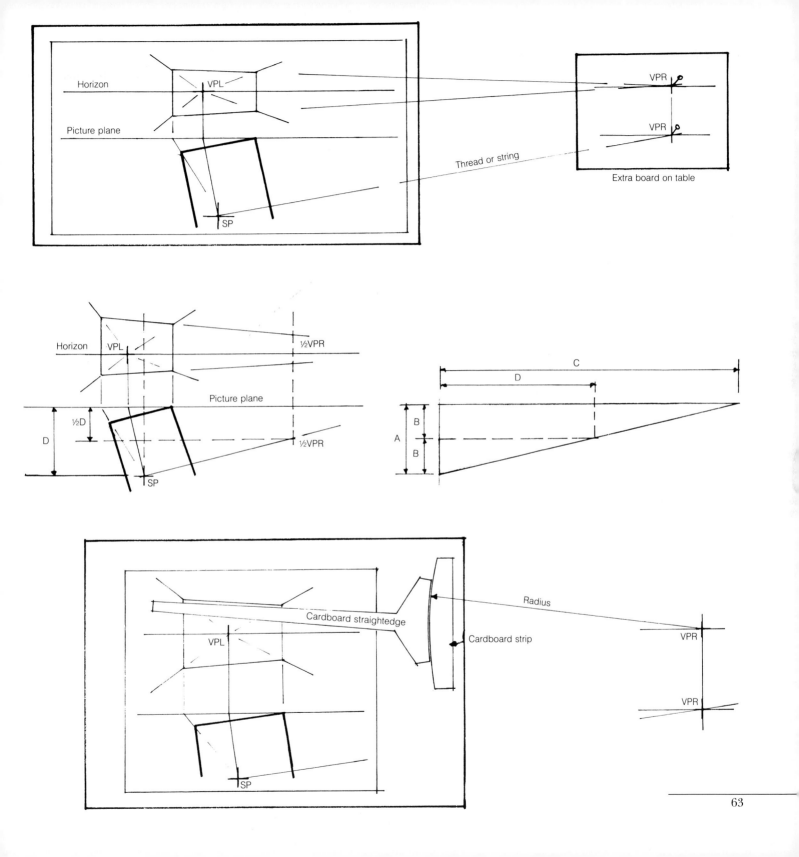

Horizon

VPL

Picture plane

Thread or string

VPR

VPR

Extra board on table

SP

Horizon

VPL

½VPR

Picture plane

½D

½VPR

D

SP

C

D

A

B

B

Cardboard straightedge

Radius

Cardboard strip

VPR

VPR

VPL

SP

CIRCULAR FORMS

Circles seen in perspective require special care in layout because the eye is very critical in noticing and rejecting anything that appears as a distortion. When viewed directly, any circle seen foreshortened in perspective will appear as an ellipse. A circle placed near the edge or corner of a perspective may appear to be distorted (as can often be seen in photographs). However, if the circle were actually correct in layout, it would only appear correct if the viewer looked fixedly at the center of the drawing, thus seeing the circle only "out of the corner of the eye." In practice, the viewer's eye will, at some point, look directly at the circle and reject it as "badly drawn" because it does not appear as an ellipse.

The method of placing circles in perspective using a grid of squares is technically accurate, but produces circles that appear to be distorted unless they are close to the center of the view. It is generally preferable to use an alternative method in which the circle will appear as an ellipse. Using this method requires an understanding of ellipse form and mastering the technique for sizing and placing the appropriate ellipse in the correct position in the perspective. A number of ways to use the ellipse method are discussed here first and recommended as most efficient. A description of the "grid-of-squares" method follows as a matter of information.

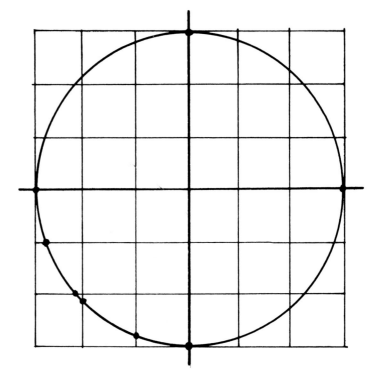

Circle converted to perspective by the grid-of-squares method. This example places the circle on center in a one-point perspective and so appears quite acceptable.

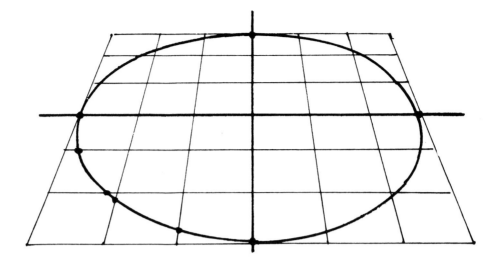

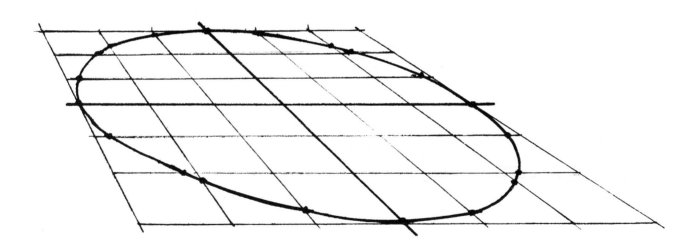

Circle drawn by grid-of-squares method, but located at far right in a one-point perspective. The sense of distortion is apparent, with form appearing to "run downhill" to the right.

The ellipse is a geometric figure having a precise mathematical and geometric description. To be an acceptable perspective representation of an obliquely viewed circle, the ellipse form must be perfectly drawn and properly positioned. Ellipse guide templates are available to make the drawing of perfect ellipses easy, but a full range of sizes and proportions demands a large (and expensive) set of guides, and some ellipses may still be required that do not exactly match any guide. In practice, a few guides are helpful for drawing most smaller ellipses and also for learning correct ellipse form. Drawing ellipses without a guide and understanding how to place ellipses, with or without guides, requires an understanding of the "anatomy" of the ellipse.

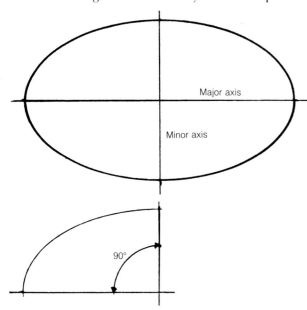

Cutting a cylinder with a plane at an angle to the cylinder's axis produces an elliptical section. Similarly, cutting through a dowel or a mailing tube at an angle will produce an elliptical form. The angle of the cut will determine the proportions of the ellipse, which can vary from "fat," almost circular, to "flat," the result of a cut at a sharp angle.

The longest dimension of the ellipse is called the *major axis*, and the shortest dimension is called the *minor axis*. These two axes are always at right angles and divide the ellipse into four quadrants that are identical in form.*

Arriving at the ellipse that will represent a circle in perspective involves determining the direction of the minor axis, establishing a major axis at right angles to the minor axis, and determining the lengths of each of the axes. A suitable ellipse can then be drawn with the aid of a template or "by eye." Note that the center of the ellipse (where the axes intersect) will not coincide exactly with the center of the circle placed in perspective, although the minor axis will pass through that center. The direction of the minor axis will be the direction of the axis of a cylinder that has the circle to be represented as its end. Whatever the size, proportions, and position of the ellipse, its four quarters will be identical, and its line will be a continuously changing curve. Its form can be studied with guide templates, or by drawing ellipses with the pin and thread method.

Notice that there are no "flat spots" in any ellipse and that its ends, no matter how "flat," are never pointed. Setting up the appropriate ellipse is usually best done by enclosing the circle to be represented in a square, placing the square in perspective, and then fitting an ellipse into this "box." Take care that the minor axis is properly positioned.

A circle in a horizontal plane will have a minor axis that is vertical and a major axis that is horizontal. To draw such a form, begin by surrounding the circle in plan with a square. Place this square in perspective and find its center by drawing two intersecting diagonals. Draw a vertical through this center to indicate the location and direction of the minor axis of the required ellipse. Now fit an ellipse to the square "box," keeping its major axis horizontal. Making the ellipse tangent to the square

*A true geometric ellipse can be constructed with pencil, thread, two pins, and straightedge. Draw the major and minor axes at right angles. Place two pins symmetrically on the major axis at points equidistant from the minor axis. Tie thread to the two pins, leaving enough slack so that a pencil placed in the loop of thread will just reach an end of the major axis. Now draw an ellipse with the pencil in the thread loop, constantly keeping the thread taut as the pencil moves. Changing the pin locations and the slack in the thread loop will make it possible to draw an ellipse of any desired proportions.

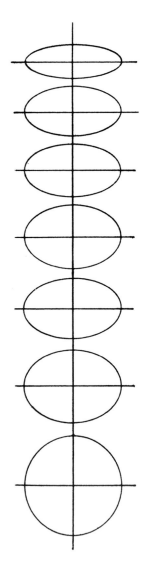

Far left:
A typical ellipse. Major and minor axes form 90° angle; four quarters are identical.

Below:
Ellipses with same major axis but diminishing minor axes from bottom to top.

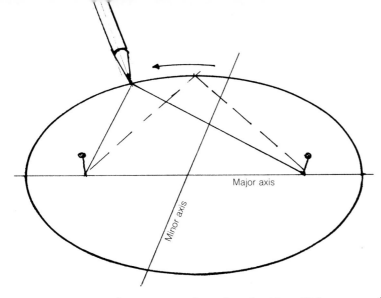

minor axis and makes it possible to fit an appropriate ellipse to the box.

Do not be disturbed that the angles of the major and minor axes may look odd and seem unrelated to the rest of the drawing. The ellipse they determine will appear correct once it is in place. Note that in a one-point perspective, the minor axis will always be horizontal (angled toward the infinitely distant and therefore nonexistent vanishing point). This means that the major axis will necessarily always be vertical. Notice again that the intersection of the axes of the ellipse will not coincide with the center of the circle determined by the intersecting diagonals, although it will be close to it.

at the center point of each side will be easy when the circle is close to the center of the drawing. If it is near an edge or corner, this may be difficult.

Resist any temptation to tilt the ellipse, even if this means that the "fit" to the square box is not perfect. An ellipse with a horizontal major axis will "look right," even if it cannot be made to fit perfectly within the square. The ellipse that represents a circle near eye level is often difficult to draw because it will have a very short minor axis. A circle that is exactly at eye level will, of course, appear as a straight line. Since this situation is not clearly understandable in a drawing, it is best to avoid it by moving the circle either up or down, so that it can be shown as elliptical.

A circle in a vertical plane will have a minor axis angled toward a vanishing point. Here again, it is best to begin by placing a square box in perspective that will enclose the circle. The sides of the box will be verticals located as any other vertical line position would be, while top and bottom lines are set by measurement along a height line, with lines extending forward from the appropriate vanishing point. The center of the circle can now be located by drawing two intersecting diagonals of the square. A line through this center angled toward the *other* vanishing point (not the one used to set the top and bottom lines) will establish the direction of the minor axis. The major axis must be at right angles to the

Circles placed at odd angles do not often occur in interior perspectives. If called for, the appropriate ellipse is determined by placing a square enclosing the circle in perspective, finding its center with intersecting diagonals, and then drawing a line for the direction of the minor axis through this center. The direction of this line can be arrived at by imagining a cylinder having the circle as its end. The axis of this cylinder will determine the direction of the minor axis. Once again, the major axis will be at right angles to the minor axis, and an appropriate ellipse can be fitted to the enclosing square box using these axes.

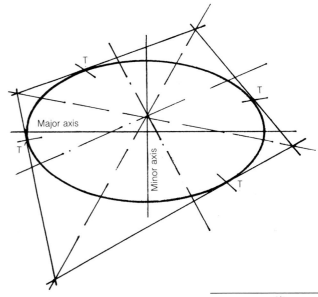

Above right:
Constructing a true ellipse with pins and thread.

Far right:
A square enclosing a circle placed in perspective with a true ellipse fitted into place. Note that points of tangency T do not coincide with center lines of the square, nor with the axes of the ellipse. Note that the center of the square (determined by crossed diagonals) does not correspond to the intersection of the axes of the ellipse.

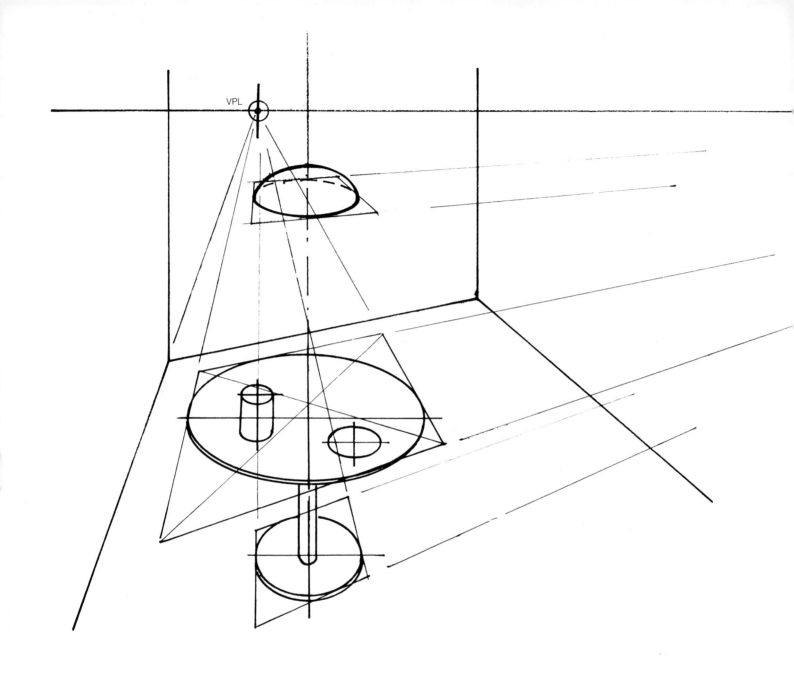

VPL

*Circles in a horizontal
plane represented by true
ellipses "fitted" to enclosing
squares. Note that the circle
developed by grid-of-squares
method (right), although
geometrically correct, ap-
pears to be distorted.*

The grid-of-squares method for placing circles in perspective also involves enclosing the circle in a square. The square is then subdivided into a grid of equal smaller squares—36, 64, or more—according to the size of the square. A true circle is drawn in a square similarly divided for use as a reference. The square and grid are now placed in perspective. By referring to the true circle and its grid, the points where the circle crosses the grid are identified and transferred to the grid in perspective. By connecting the points, a perspective representation of the circle can be drawn. It will be found that this method generates an ellipse or near ellipse when the circle in question is near the center of the drawing. Circles near edges or corners of the drawing may seem oddly distorted and are best replaced by ellipses placed according to the methods outlined earlier.

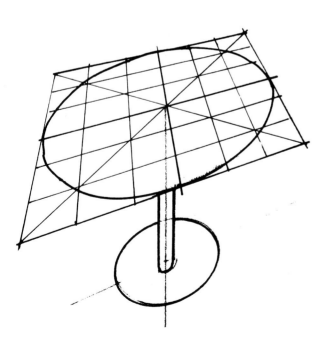

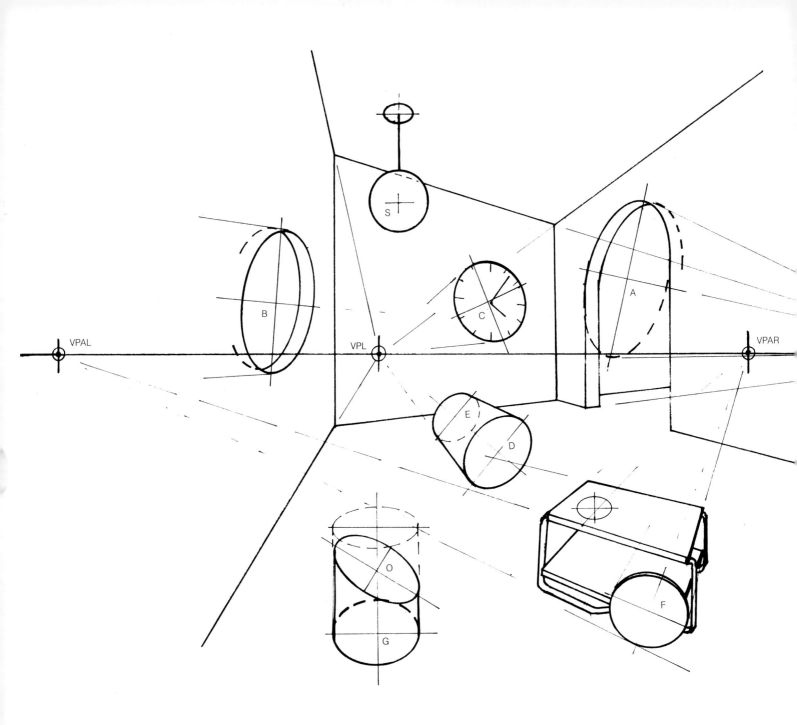

VPAL

VPL

VPAR

S

B

C

A

E

D

O

G

F

Parts of circles, such as semicircular arches, curved seating groups, or curving walls, can be drawn by constructing the full circle in perspective (or as much of the full circle as is convenient) and then using tangent straight lines to establish the beginnings and ends of the arc required. Spaces that are circular (rotundas, for example) are drawn by setting up wall-to-floor intersections and other circular lines in horizontal planes in the usual way.

Circular (or spiral) staircases pose an interesting problem in perspective drawing and were often shown in classical treatises on perspective as demonstrations of skill. The cylinder enclosing the stair is first set up in perspective, then ellipses are drawn at the level of each stair tread. Vertical lines are placed to define the locations of risers. Steps can then be drawn one by one in sequence. The process is laborious but not difficult. The helical (spiral) lines of rails or other sloping elements of a spiral stair are drawn by connecting the step edges and, for a rail, measuring upward from each step. The resulting points are then connected with a continuous curving line.

Irregular curves (not parts of circles) are best drawn with some version of the grid-of-squares method. Points along the curve are located in perspective and connected with a curving line drawn with French curves or freehand. The eye is much less critical of irregular curves than it is of circles, so that minor inaccuracies in drawing such curves will not be readily detected and are therefore not serious.

A sphere in perspective always appears as a true circle and so can be drawn with a compass or circle guide. Lamps or light fixtures with spherical globes are often encountered in drawing interiors, but occasionally a sculptural element may also turn up. Locate the center of the sphere in plan, note the height on the height line, and place the center in space using sight lines and construction lines. Use sight lines carried back to the picture plane in plan to establish the apparent diameter. It is then simple to draw in an appropriate circle.

orizon VPR

Circles in vertical planes and oblique positions. A and B have minor axes angled toward VPR. C, D, and E have minor axes radiating from VPL. The minor axis of F angles toward VPAR. G is in a horizontal plane with axes vertical and horizontal. O is actually an ellipse resulting from the cylinder being cut off at an angle. Its perspective representation is another ellipse fitted to the geometry of the form. S is a sphere and so appears as a true circle in any view.

Far right:
Spiral stairs developed from plan (bottom) to plan in perspective (ellipse), and then into perspective view.

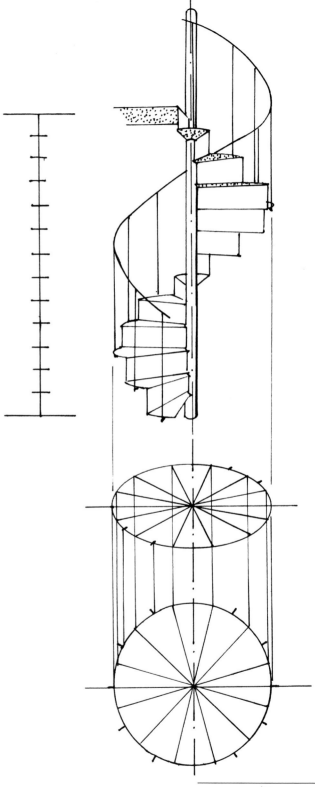

REFLECTED IMAGES

Reflections that appear in mirrors, in pools or other water surfaces, or in highly polished surfaces often need to be shown in perspective and may, at first, present something of a puzzle. All reflections can be dealt with by imagining that the actual space being viewed exists in an identical but reversed form in the reflection. When the reflecting surface is horizontal (as in a pool, a polished floor, or a mirrored ceiling) the reflected image is reversed vertically, that is, it is upside down. When the reflecting surface is vertical (as in a mirrored or glass wall or a highly polished wall surface), the reflected image is reversed right to left.

In each case, the image is placed in per-spective as if it were an actual space extending up, down, or to either side. As much of the complete reflected image as required should be constructed to show the reflection. A fully mirrored wall will appear as a complete space duplicating the space being shown, but reversed. A smaller mirror can be thought of as a window looking into such a twin, reversed space. A reflection in a pool is similarly drawn as if the pool were an opening in the floor permitting a partial view of an inverted room lying below. Note that the real and the reflected image meet along the line of the reflecting surface's plane. No separation space (for wall thickness, for example) is created between the actual and reflected images.

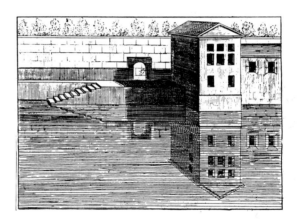

Reflections in perspective as illustrated in Traité de Perspective . . . *by Edme-Sebastien Jeaurat, published in Paris in 1750.*

A reflected plan is drawn as a basis for the image "behind the mirror." Since there are both a reflecting pool and a mirror here, there is a reflection of the pool in the mirror, and of the mirror in the pool.

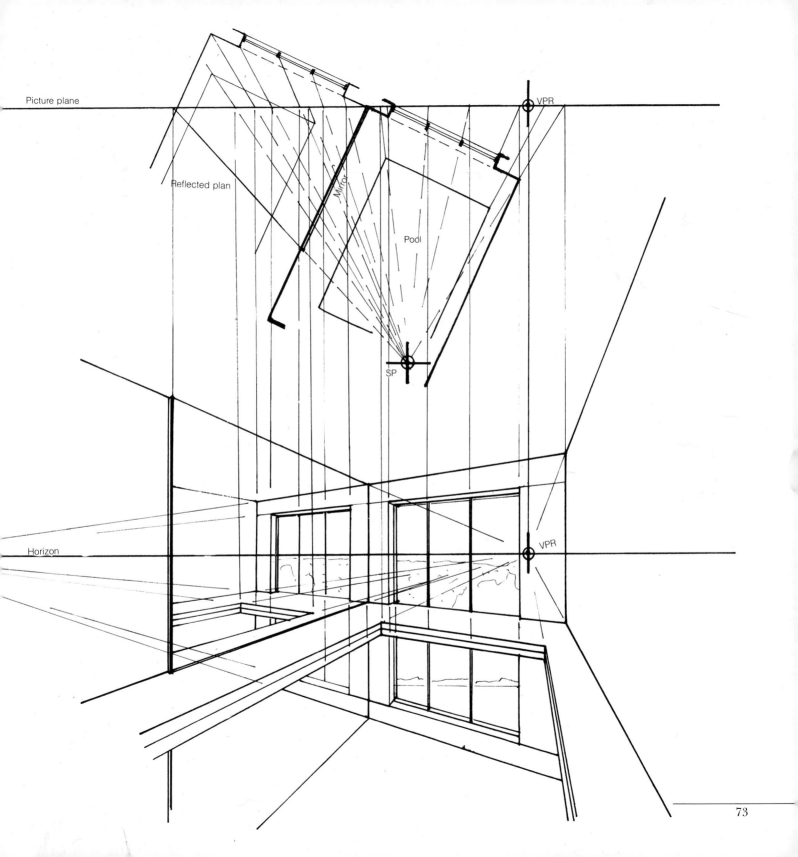

Picture plane

Reflected plan

Mirror

Pool

SP

VPR

Horizon

VPR

SECTIONAL PERSPECTIVES

It is often effective to develop a perspective in which spaces are shown extending inward from a sectional drawing. This can be helpful in explaining how various rooms within a building relate to one another or how the whole internal organization of a building is worked out. Sectional perspectives are most often one-point drawings. A scale section serves as a starting point, and the picture plane is usually located to coincide with the section. Spaces are then shown as receding in depth behind the picture plane section.

To draw such a view, place a plan on the board with its axes horizontal and vertical. Draw a section line across the plan and draw a section corresponding to the section line above or below the plan. Place a station point on the plan far enough back from the section line so that the whole section to be shown will fall within a reasonable cone of vision. Draw a horizon line across the section at a desired eye level. A vanishing point can now be located by bringing a line vertically from the station point in plan. Sight lines can then be drawn in plan from the station point back to significant points in the plan. Where these sight lines intersect, the section line (picture plane) determines the location of vertical lines.

Lines drawn outward from the vanishing point and connecting corners in the section with verticals representing the rearmost corners of interior space will denote edges of floors and ceilings. Other elements are located similarly within the visual space developed.

A sectional perspective can also be drawn with two-point construction, although this is rarely done. It requires placing the plan with its section line at an angle with the picture plane, which is positioned to pass through the near corner intersection of section line and a

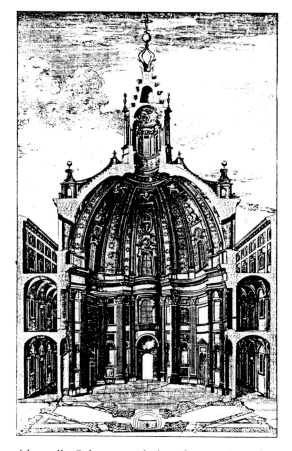

A sectional perspective of Borromini's Sant' Ivo della Sapienza, Rome, from Opera del Caval. Francesco Borromino . . . of 1720. *The sectional view makes clear spatial relationships that cannot be seen or photographed on site. Note the plan in perspective extending into the foreground.*

Sectional perspective developed with a picture plane placed at the section line A-A.

side wall of the space being drawn. A station point is established and two vanishing points placed in the usual way. The near edge of the section becomes a height line in the perspective, and spaces are developed with sight lines and lines radiating from the appropriate vanishing points as in any other two-point construction. As in one-point sectional perspectives, the unusual feature here is the placement of the picture plane at the front of the space being drawn rather than at the rear.

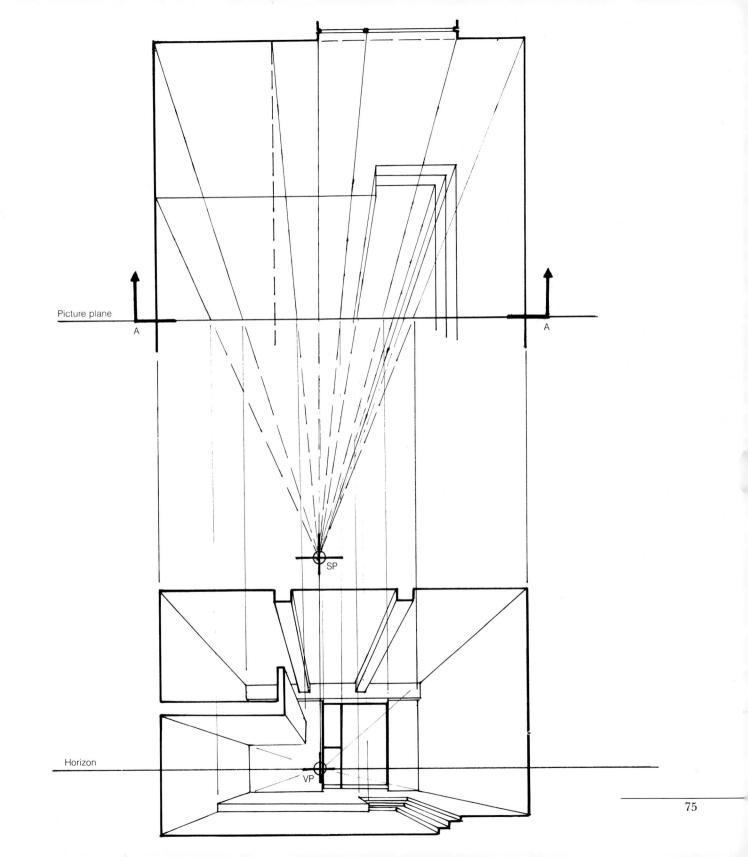

Picture plane

A A

SP

Horizon

VP

VIEWS FROM ABOVE

A perspective showing interior space as seen from directly above (with ceiling removed) can be very useful in explaining plan layout of spaces. The drawing will resemble a view downward into a scale model—in no way realistic, but often interesting and informative. Views of this kind are also most often constructed as one-point perspectives. A scale plan drawing is used as a basis, but it is treated as if it were the back wall of a typical one-point view of a room. A single vanishing point is located somewhere in the plan, usually near its center. Lines now radiate outward from the vanishing point through the corners of the space or spaces being shown to represent vertical corners as seen from above. The height of the space being shown is often established arbitrarily "by eye," but can be accurately established by using an elevation in the role in which plan is normally used.

Below the plan, which forms the "floor" in the perspective, place an elevation horizontally in correct relation to the plan. Place a station point far enough back to allow for a cone of vision to include all of the plan. Draw a sight line from the station point through a near corner of the elevation onward to a pic-ture plane drawn through the top horizontal of the elevation. A vertical taken upward from this intersection will establish the top edge of the spaces shown in the perspective.

This step may seem confusing since the sight line will be passing through a corner of the floor shown in elevation and continuing on to the picture plane set at ceiling level. But it will yield the same result that would be produced by using an inverted elevation with the picture plane placed at floor level. Once one vertical in perspective has been drawn, ceiling level lines can be used to follow around each space to connect with lines brought "up" from the plan radiating from the vanishing point.

A view from above can also be developed by drawing spaces as if they extended downward from the plan used as a starting point. The technique and the results will be similar—the method of working is a matter of choice. It is also possible to develop a view from above by placing the plan in either one- or two-point perspective and introducing vertical lines representing height dropped downward from the appropriate corners of the plan. Such a drawing will closely resemble a normal view of a model seen with roof or ceiling removed.

Offices for Dial Financial Corp. A one-point perspective from above gives a model-like quality which is helpful in explaining a plan layout to laymen not familiar with architectural plans. (Design and drawing by John Pile for Sandgren and Murtha, Industrial Designers, New York.)

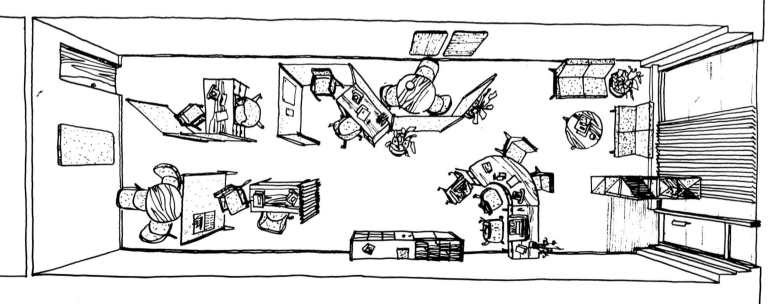

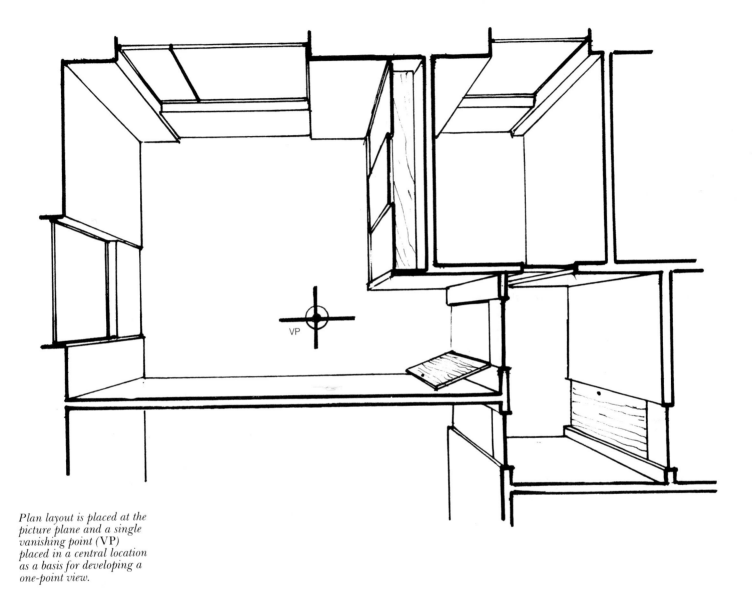

Plan layout is placed at the picture plane and a single vanishing point (VP) placed in a central location as a basis for developing a one-point view.

UPWARD AND DOWNWARD VIEWS

In almost all interior perspectives, the line of vision is assumed to be horizontal—that is, directly toward the horizon. In such views all verticals are shown as truly vertical in perspective. In actuality, a viewer can tip the head and/or roll the eyes upward or downward to take in an angle of view that is not horizontal. When the line of view is tipped in this way, verticals will seem to converge toward an additional vanishing point above or below the horizon. This effect is familiar in photographs of tall buildings where the verticals converge upward making the building seem to tip backward. To achieve this effect in a drawing, it is necessary to introduce a third vanishing point. This is known as "three-point perspective."

Accurate geometric construction of a three-point perpsective is complex and troublesome. It requires a large drawing board to permit placement of the third vanishing point. In practice, three-point perspectives are most often made by constructing a two-point (or one-point) layout and then altering the verticals so as to make them converge toward a high or low vanishing point that has been placed somewhat arbitrarily "by eye." Interior perspective drawing rarely calls for sharply upward or downward views. An occasional exception might be a view directly down into a stairwell or a view up into a shaft or skylight. Such views can usually be handled as one-point perspectives in which the space to be shown is thought of as having been turned on its side. The problem of depicting a well or shaft thus becomes similar to that of drawing a corridor and can be set up in one-point perspective accordingly.

It is interesting to note that in architectural photography, the effects of three-point perspective, with its leaning verticals, are considered undesirable. Ordinary cameras create these effects whenever tilted up or down, and considerable effort goes into avoiding or "correcting" such effects. Further discussion of this matter is included in Chapter Four, which deals with studying perspective with the camera.

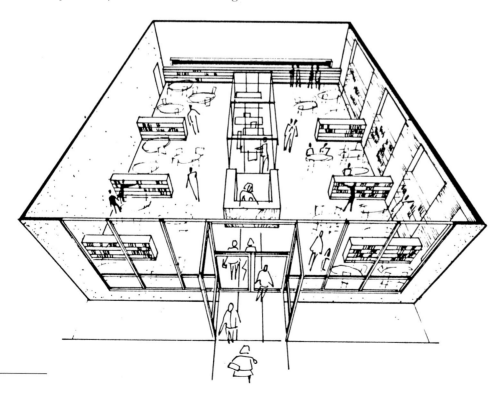

A library interior viewed from above. This is an unusual two-point view because one vanishing point (to the rear) develops the plan in one-point perspective. The second vanishing point is below to deal with vertical lines. (Design and drawing by Victor Yohay, architect.)

VPL

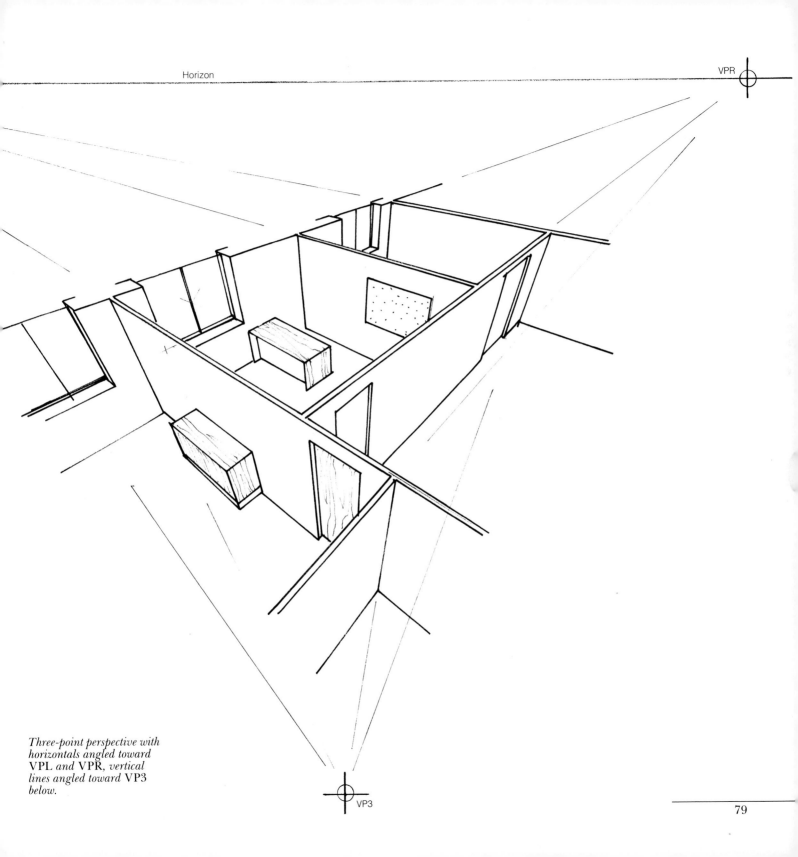

Horizon

VPR

VP3

Three-point perspective with horizontals angled toward VPL *and* VPR, *vertical lines angled toward* VP3 *below.*

LIGHT EFFECTS: SHADE AND SHADOW

Basic perspective normally deals only with the layout of objects defined by lines. Realistic effects called for in partially or fully "rendered" drawings involve representation of the effects of light. Representation of light effects can be managed in some degree by simply imagining what surfaces will be lighter or darker, or where shadows are likely to fall. More precise representation of light effects can be developed geometrically in plan and elevation if the source of light has a known (or assumed) location. Such geometrically developed shading and shadows can then be placed in perspective, just as if they were actual fixed patterns of materials or color.

In formal architectural drawing, conventions as to how to indicate shade and shadow have been developed. For example, it is customary to assume that light always comes from a source (presumably the sun) located so that it falls down, backward, and to the right at an angle which appears as 45° when shown in orthographic projection. Some architectural drawings of traditional interiors follow this convention, although it can hardly be considered logical or realistic when applied to interiors.

A more realistic approach involves imagining the actual sources of light in an interior and representing the patterns of shade and

Sunlight patterns formed by light entering windows. Parallel construction lines at angle of sunlight are used to locate corners of light pattern forms.

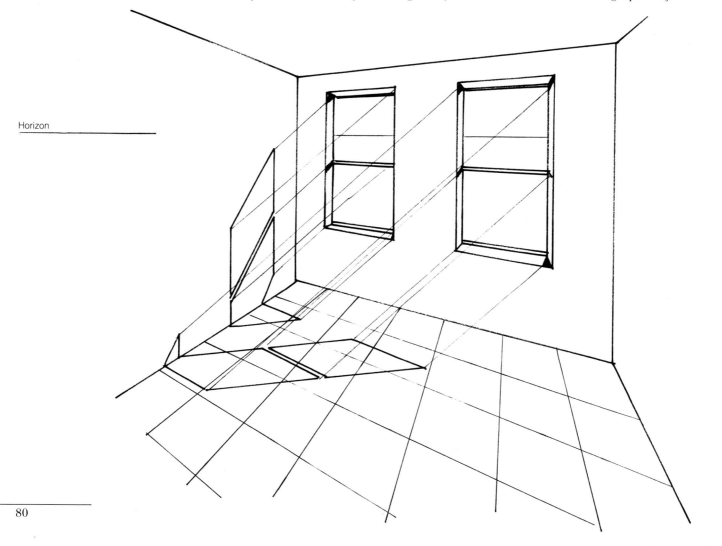

Horizon

shadow that will result. Real interiors are often illuminated in different ways at different times and by several sources of light at the same time. For example, some interiors have direct sun and diffused light from the sky as well as several sources of artificial light. Thus, accurate rendition of interior lighting effects can be complex and confusing. Diffuse lighting of the sort that comes from north windows, from all windows on cloudy days, or from indirect artificial lighting generates no strong patterns of shade or shadow and so requires no particular representation. (Indicating the dimming of light under furniture or other obstructions should be considered a concern of rendering.)

Strong sunlight coming in windows or other openings creates sharp patterns that can be drawn as areas of full sun and shadow. It is necessary to assume a position for the sun (a point located at infinity) so that light patterns cast by the sun can be developed geometrically. The "beams" of sunlight can be viewed as solids generated by planes passing through openings along their edges. As these solids intersect floor or wall (or other planes), they create the familiar patterns of sunlight that we often see. Since these patterns are usually regular forms with edges in systems of parallels, vanishing points can be set up to aid in their layout.

Sunlight patterns from larger window opening with shadows cast by railing outside.

Horizon

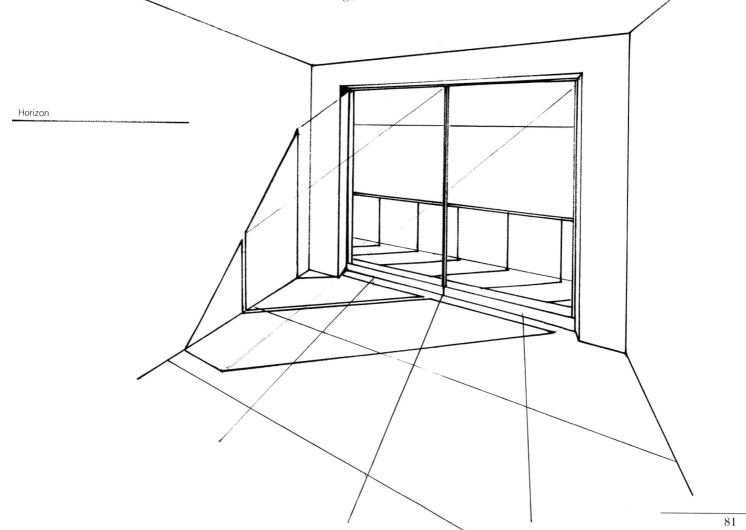

The sunlight patterns most often found significant are forms cast on floors and on walls close to windows. Artificial light with point sources (lamps with incandescent bulbs, downlights, etc.) also cast noticeable shadows. A lamp on a table, for example, will usually cast a well-defined shadow on the floor. Such a shadow can be thought of as the base of a pyramid having the light bulb as its apex, the table top as a horizontal plane defining its shape and size, and the shadow as its base. Furniture tends to cast shadows, more or less well defined according to the nature of the light source. Geometric construction of such shadows is possible as soon as the position of the light source is identified.

"Shade" is the term used to describe the diminished light on surfaces not receiving light (as distinguished from the "cast" shadow which is projected onto another surface). Wall surfaces penetrated by bright windows are generally "in shade" as are surfaces of furniture and other objects that face away from light sources. Indication of shading through the use of tones is more a concern for rendering than for drawing, but it may be helpful

Sunlight patterns plus shade and shadow generated by window divisions and furniture. In rendering, light and dark tones would make these patterns more striking.

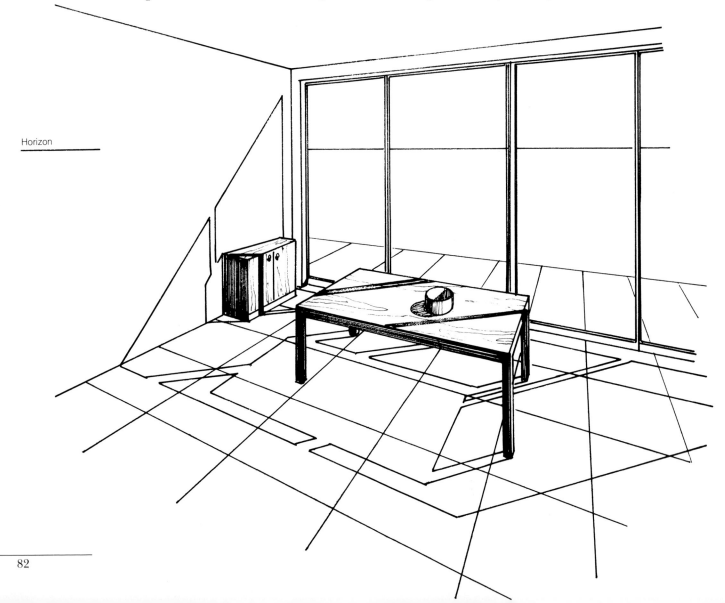

Horizon

for the designer to indicate shaded surfaces (with tone) as a drawing is being developed and shadows indicated.

Some other effects of light, such as "beams" from an intense light source or a spotlight, may also be indicated in perspective drawings. Geometric layout proceeds as if the visible beams of light were actual cones or cylinders moving through the space from the source to the surfaces they illuminate. Realistic development of such lighting effects is also a concern of rendering rather than of drawing.

Study of interior lighting effects as they appear in real life and in photographs is generally helpful in developing convincing patterns of light, shade, and shadow in drawings. Since light sources are so variable, no one "correct" way of representing light and shade in any space can be identified. Any indication that is convincing and helpful in defining the space being drawn can be useful, but it should also be remembered that most line perspectives ignore all indication of light and shade and still give a convincing rendition of form.

Shade and shadow patterns generated by a point source artificial light within the space drawn. "Rays" extending from the light source are used to locate key corners of shadows.

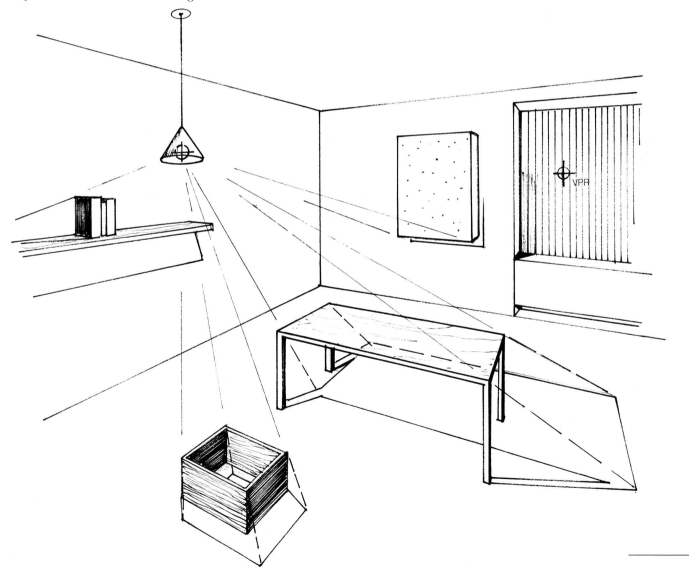

FURNITURE IN PERSPECTIVE

Placing furniture in perspective seems to present special difficulties. Furniture is often angled so that it is not in one of the main systems of parallels representing a space. It often includes curved, sloping, or other irregular forms and is also often of known and recognizable identity so that any error in drawing becomes painfully obvious. Chairs with one leg floating strangely in the air and tables with tops slanting alarmingly are all too common problems in beginners' interior perspectives.

The basic construction of furniture forms follows the same rules that govern any other perspective construction, but it is convenient to set up new vanishing points for individual pieces of furniture that stand at angles with walls. Doing this on an overlay sheet can help to minimize the confusion of lines that can otherwise be created. Complex furniture forms are best dealt with by developing an imaginary box to enclose the object, placing the box in perspective, and then drawing the piece of furniture within the box. This is best done by:

1. Drawing the piece of furniture in correct scale and in its correct location on the plan of the space.

2. Placing the plan in perspective by using sight lines to establish corners. If the object is placed "square" with the walls of the space, the regular vanishing points may be used. If it is at an angle, auxiliary vanishing points may be established. The four corners of the plan in perspective should establish lines that angle toward the appropriate vanishing points, regular or auxiliary as the case may be.

A grouping of furniture placed in plan perspective. Auxiliary vanishing points VPC (for the chair on the right) and VPT (for the round table) are developed as a convenience.

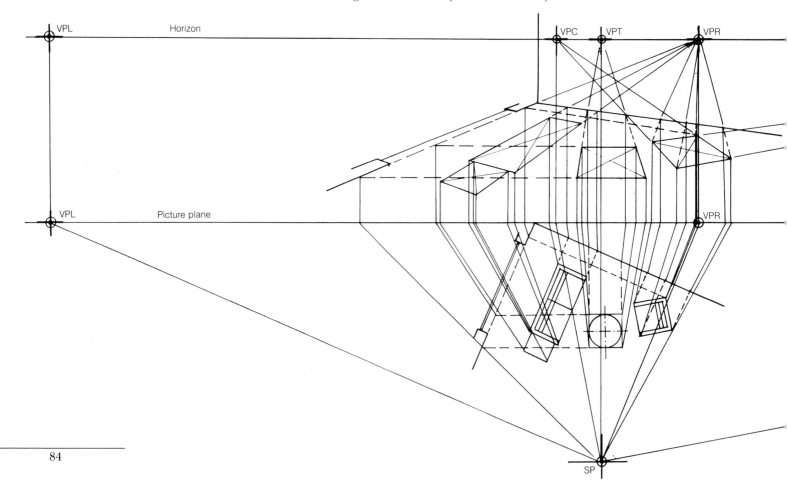

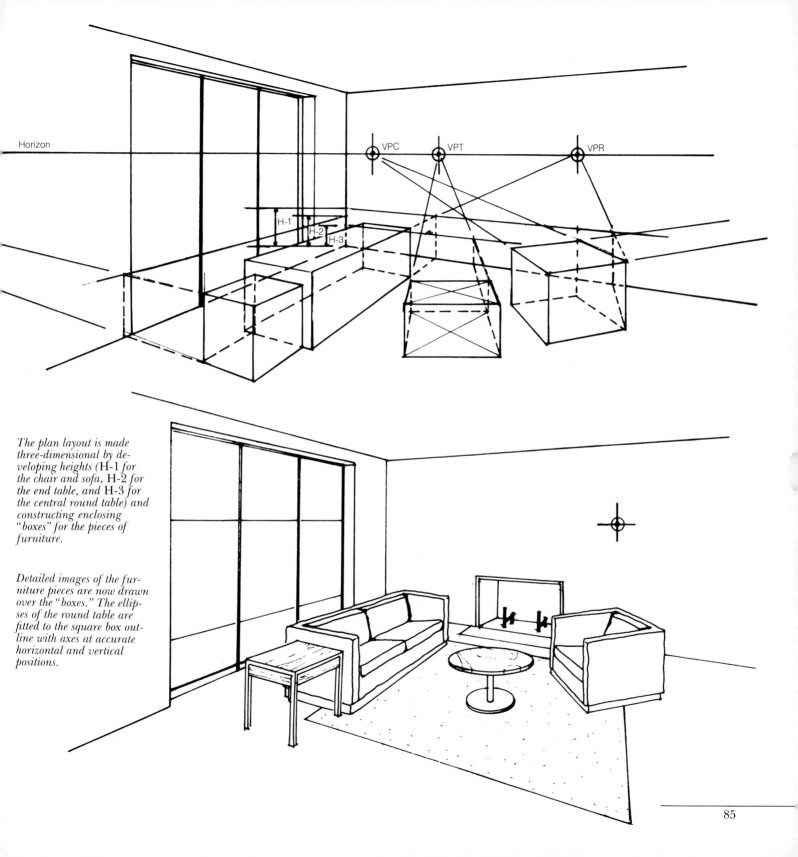

Horizon VPC VPT VPR

H-1

H-2

H-3

The plan layout is made three-dimensional by developing heights (H-1 for the chair and sofa, H-2 for the end table, and H-3 for the central round table) and constructing enclosing "boxes" for the pieces of furniture.

Detailed images of the furniture pieces are now drawn over the "boxes." The ellipses of the round table are fitted to the square box outline with axes at accurate horizontal and vertical positions.

85

3. The height of one corner of the enclosing box is now established by leading lines outward from the main height line. The box can now be completed with verticals rising from the plan and horizontals angled toward the appropriate vanishing points. Additional heights may be established for elements in a chair such as height of seat, height of arm, or location of stretchers.

4. An outline drawing of the main elements of the object can now be drawn into the box. If a known furniture design is being represented, it is helpful to have a photograph at hand. Once the "skeleton" drawing seems to be satisfactory, a more realistic and detailed drawing can be developed. This can be done on an additional overlay sheet if it will help in maintaining clarity.

Note that circular elements (round table tops, chair seats, and curved sofas) must follow the rules governing the drawing of circles in perspective. Round table tops *must* appear as ellipses with a horizontal major axis, wherever located. Any other form will look disturbingly tilted.

Before drawing any known furniture into an interior drawing, it is helpful to trace one or more photographs after establishing a horizon and vanishing points for the photographic image. How to do this is discussed in Chapter Six. Do not try to fit the photographic image into the drawing in progress—it will almost never fit—but use it for practice in developing an understanding of the furniture form as it appears in perspective.

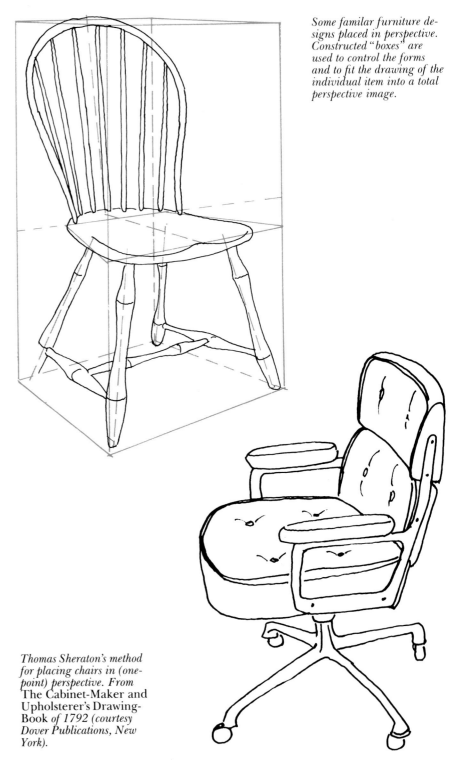

Some familar furniture designs placed in perspective. Constructed "boxes" are used to control the forms and to fit the drawing of the individual item into a total perspective image.

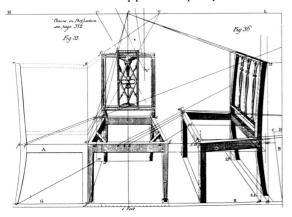

Thomas Sheraton's method for placing chairs in (one-point) perspective. From The Cabinet-Maker and Upholsterer's Drawing-Book of 1792 (courtesy Dover Publications, New York).

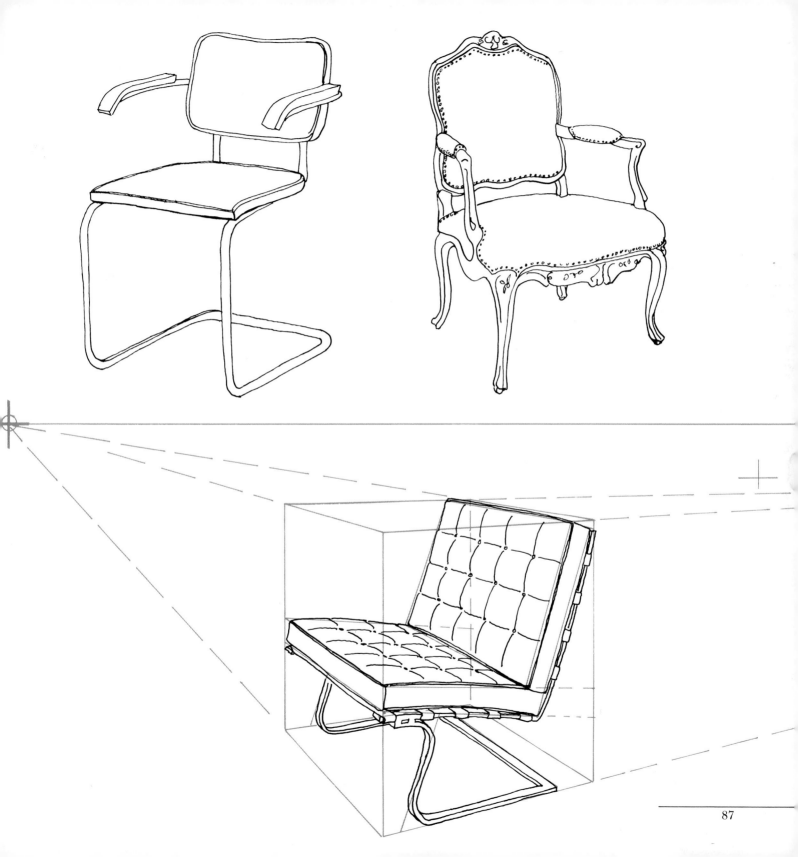

SOME PERSPECTIVE SHORTCUTS

Construction of geometrically accurate perspectives may seem to be complex and laborious at first. Thus it is easy to see why various methods and gadgets that promise shortcuts are so tempting. In general, special instruments, charts, and trick "methods" turn out to be limiting and in the end seldom save any effort. There is nothing inherently wrong with using a perspective chart for example, but it will force the acceptance of a particular angle and viewpoint (or one of several, each requiring its own chart). Sticking to one-point perspective, using a grid of squares on the floor to locate objects, and other such techniques often suggested in books on drawing are also possible. But, again, they limit the designer's flexibility and do not in the long run save much effort. Once the general methods outlined in this book are mastered, setting up and drawing *any* perspective will become quite easy and make such limiting devices pointless.

Following are six techniques that are genuine shortcuts and work within the basic methods described in this book.

1. Use crossed diagonals to locate centers. The center of any square or rectangle can be found easily and accurately by locating the point at which two diagonals cross. This is useful in halving any form (finding the center of a pair of double doors, for example) and can be turned to further use as described later on.

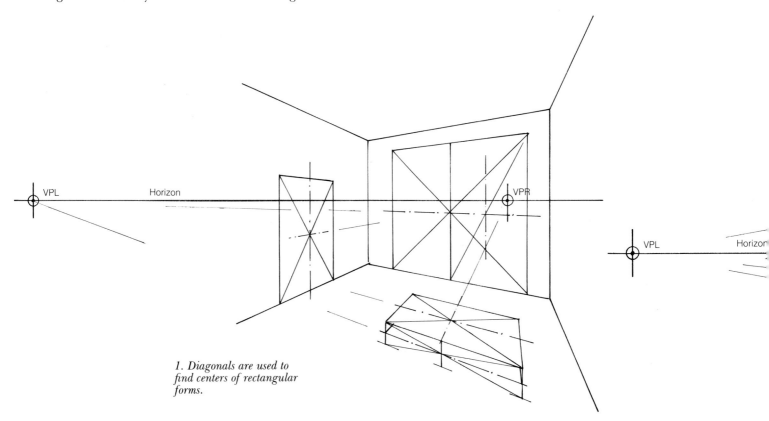

1. Diagonals are used to find centers of rectangular forms.

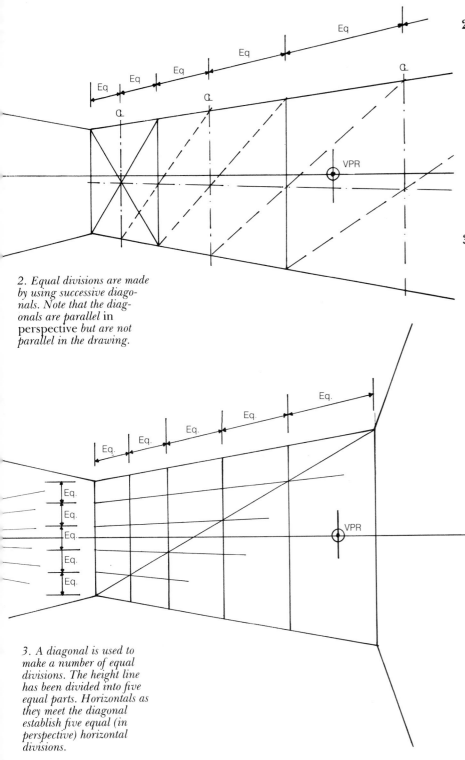

2. Equal divisions are made by using successive diagonals. Note that the diagonals are parallel in perspective but are not parallel in the drawing.

3. A diagonal is used to make a number of equal divisions. The height line has been divided into five equal parts. Horizontals as they meet the diagonal establish five equal (in perspective) horizontal divisions.

2. Get repeated equal units through use of diagonals. If the center lines of any square or rectangular form in a vertical plane are found, a construction line can be drawn connecting a top or bottom center point with a center of one side. If this line is then continued to an extended bottom or top line, it will establish the half dimension of the next adjacent unit of the same size and shape. Repeating this step makes it easy to lay out a range of equal units without using sight lines for each. This is a quick way to lay out divisions of wall panels, window muntins, and other elements that involve repeated equal divisions.

3. Do proportional division of space by use of diagonals. It is often convenient to subdivide a unit of space in the lateral direction by dividing the height line in the desired relationship and then using a diagonal across the total space to be divided in order to establish the needed subdivision of the width dimension. Perspective lines running horizontally from the height line intersect the diagonal in the correct proportional ratio in perspective.

4. Use diagonals to develop repeated squares in a horizontal plane. Square floor units (tile or parquet) and squared ceiling materials are so common that it is convenient to use a shortcut for laying these out. Construct one square at a corner of the space using sight lines to set each dimension. A diagonal of this square can then be used as a construction line to generate additional squares from parallels laid out from points along the back wall. The original diagonal can be carried outward until it intersects the horizon. The intersection will be a vanishing point for all other diagonals of squares in the complete grid. Using these relationships can also help in layout of grids of other proportions—bricks, larger ceiling panels, light fixtures, etc.

5. Work with parallel diagonals in a vertical plane. Just as an extra vanishing point can be found for diagonals that are parallel in a horizontal plane, parallel diagonals in a vertical plane will be found to converge on a vanishing point above or below the horizon. If two successive diagonals are extended to a meeting point, that point will lie on a vertical line passing through the main vanishing point (on the horizon) related to the top and bottom horizontals. This fact can be used to aid the drawing of diagonals by extending the first diagonal drawn to a vertical rising from the appropriate vanishing point. Additional diagonals can then be drawn that radiate out from this auxiliary vanishing point as an aid in layout of repeated units.

4. Once a square in a horizontal plane is constructed, a grid of additional squares can be developed by establishing a vanishing point (VPD) for all parallel diagonals of adjacent squares.

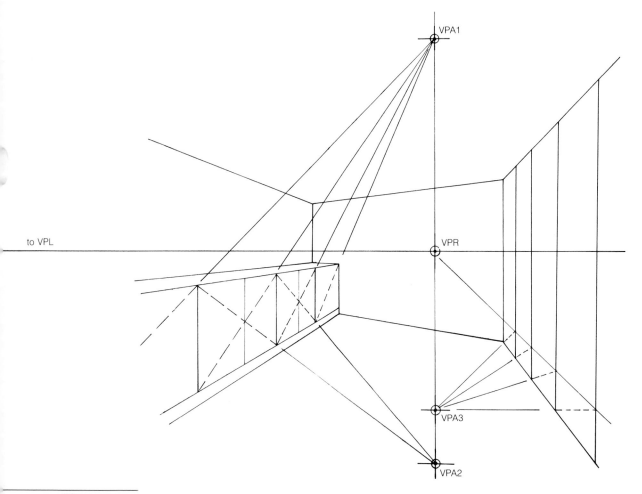

5. Repeated equal units are laid out by using diagonals. A first diagonal is continued until it reaches a vertical extended up from a primary vanishing point as at VPA1. Successive divisions are found with additional diagonals radiating from the same vanishing point. A diagonal is also used here to divide the first units in half. Two such diagonals, when extended, are found to meet at VPA2, checking the validity of the method and the accuracy of the drawings. To use the method for the tall panels on the right, a small "base" has been laid out and diagonals radiating from VPA3 set up equal divisions of the base, which also divide the wall into panels.

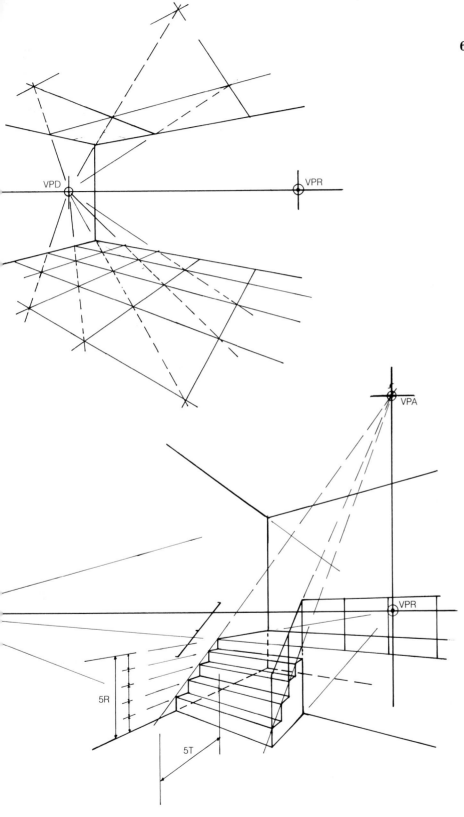

6. Use sloping lines to draw stairs. Drawing stairs can also be simplified by the use of sloping lines moving toward their own vanishing point. Set up lines representing the total height of the flight of stairs and the total length (run) plus one tread. An angled line can now be drawn representing the slope of the flight of stairs. Extend this line to a vertical extended upward from the appropriate vanishing point. The total height can now be divided into units equal to the number of risers. Lines carried back toward the appropriate vanishing point will divide the sloping line of the stair to establish points where edges of risers and treads intersect. The auxiliary vanishing point established where the sloping line intersects the vertical from the main vanishing point can be used to set up sloping lines for the second edge of the stairs, for lines of railings, and for any other related lines that follow the slope of the stairs. Variations on this geometry can deal with virtually any stair problem that may be encountered.

Once these few shortcuts are understood, they can be combined and varied in many ways that expedite drawing of perspectives that include repeating units. Describing the use of a shortcut is often far more complex than actually putting the method to use. A few minutes of practicing these six shortcut techniques will suggest additional ways of taking advantage of geometric relationships that are often surprising and interesting as well as useful.

6. Stairway construction can make use of auxiliary vanishing points such as VPA, here, to establish equal treads and risers and to establish slope of rails and stringers.

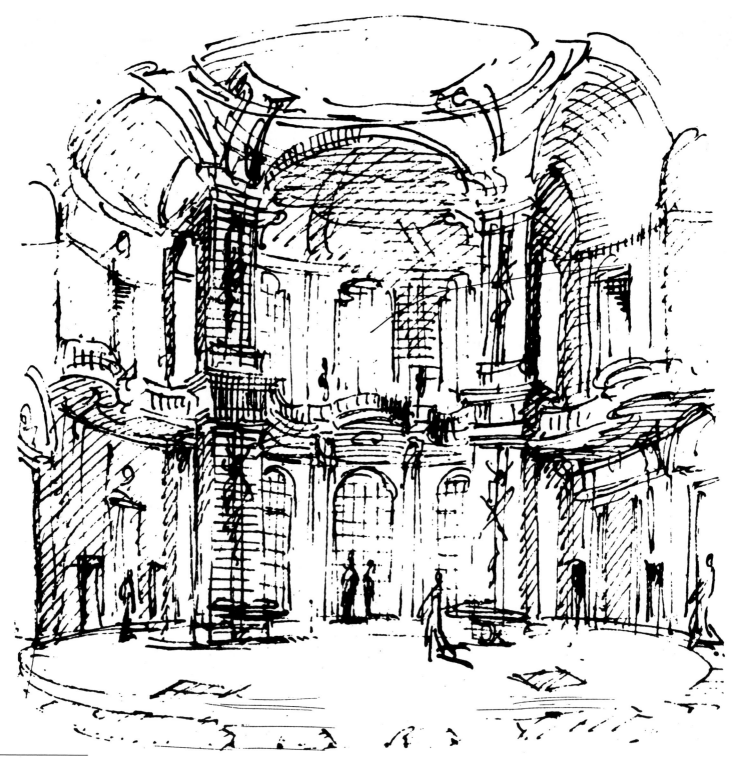

Freehand Perspective

A freehand ink line sketch by Filippo Juvarra for the great central salon of the Stupinigi Palace at Turin (circa 1729).

GEOMETRIC CONSTRUCTION of perspective drawings—that is, work based on accurate plans and elevation drawings and made with drafting instruments—guarantees the generation of accurate and convincing images. Nevertheless, freehand drawing remains a useful alternative, offering qualities that can be advantageous in certain situations. There is always a sense of personal communication, something of the "artist" in a freehand drawing that mechanical precision may limit. A perfect mechanical perspective certainly communicates authority and professional skill, but the "softer" quality of a freehand drawing can give a sense of design work in progress, of something not yet frozen into final form. It also suggests the direct "hand" of the individual making the drawing.

PERSPECTIVE BY OBSERVATION

The making of realistic perspective representations of real situations has been, at least since the Renaissance, a major aspect of the training of an artist. Traditionally, architects and designers were expected to develop a full range of artistic skills, including the ability to draw and paint "from life." In recent years, emphasis on technical aspects of design work has tended to reduce the emphasis on artistic skills in many educational programs. Carrying a sketchbook and making realistic drawings of observed situations is still a valuable way of becoming fluent in freehand drawing. The sketchbooks of such masters as Le Corbusier, Aalto, and Louis Kahn are reminders that the leading figures of modernism have remained devoted to drawing from reality as a way of studying and understanding as well as building skill for representation of their own design concepts.

Students who are beginning to draw in perspective from life often encounter confusion in converting observation into convincing imagery on paper. Lines tilt up or down, suggesting oddly leaning surfaces—furniture floats strangely in the air, circles run up or downhill or bulge in odd places. These are all evidence that although we see in perspective, we do not necessarily observe and remember the exact optical effects that control the details of observed images. Even when drawing directly from life, it is helpful to have inmind the concepts of horizon und vanishing points. Determining whether a line should slope up or down can be puzzlin until the idea of a vanishing point is considered, even if the point is never actually noted down. Knowing the theory behind the representation of circles makes it much easier for students to draw appropriate ellipses that are positioned so as to be believable versions of arches, round tables, or stools.

DRAWING OVER CONSTRUCTED LAYOUT

Another way of producing freehand perspectives is the exact opposite of drawing from life. This method is based on tracing over a constructed layout. The layout is drawn geometrically as explained in earlier chapters, but all construction lines and hidden lines can be left in place. Tracing paper (good quality "Clearprint" or yellow sketching paper) is stretched over the layout, and a freehand drawing is produced using the layout geometry. This is a favorite way of beginning a formal rendering, but the method can be used to make any sort of drawing from rough sketch to realistic presentation drawing.

The medium can be pencil, ink, marker line, or, for a rendering, tones of any desired medium that will work directly on tracing paper. For line drawing, thin-line markers are a current favorite medium, since they produce a strong line without the complications of pen and ink. When drawing over a layout, getting a precise line is relatively easy, but the slight quiver of the freehand line gives the drawing a certain softness that makes it seem more "artistic" than straightedge drafting.

When drawing over a layout, it is easy to introduce changes and modifications at will. Hidden lines are, of course, left out. Objects can be moved, added, or omitted; distortions can be corrected and awkward relationships changed. In a constructed drawing, it will often happen by coincidence that edges, corners, or lines that are part of remote elements in reality will "match up," creating an ambiguous visual condition, sometimes almost an optical illusion. Avoiding such situations in geometric layout requires shifting plan or station point and redrawing the whole layout. In an overlay, it is easy to simply "fake" by shifting one element or another a trifle to escape the unclear relationship.

Tones and textures can also be introduced to any desired degree to arrive at a result somewhere between line drawing and full tonal rendering. Addition of color is equally possible. However, black line alone makes for a drawing that is easy to reproduce by copying or printing and so is particularly suitable when such needs are anticipated.

A finished drawing on tracing paper is lifted off the underlying layout and can be stretched or mounted for protection or display. When a rendering technique is to be used that requires a material other than tracing paper (for example, when a "wet" medium is to be used, such as water color, tempera, or gouache), the layout or drawing developed over it must be transferred to the heavy paper or board to be used. This can be done by using carbon paper and drawing over the significant lines so they trace through. Commercial carbon paper makes a greasy line that is not ideal, so a "homemade" carbon paper may be substituted. This is made by scribbling with a pencil on a suitable piece of paper. An alternative is to make the line drawing with soft pencil and then turn it over on to the final paper or board (line drawing down) so that the back can be rubbed with a coin, hard pencil, or burnishing tool to make a rubbing transfer. The latter technique will, of course, reverse the drawing left to right. This will not matter for a symmetrical space, but in other cases the original layout must be reversed to allow for the transfer reversal.

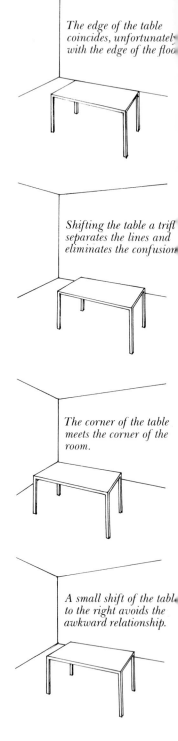

The edge of the table coincides, unfortunately, with the edge of the floor.

Shifting the table a trifle separates the lines and eliminates the confusion.

The corner of the table meets the corner of the room.

A small shift of the table to the right avoids the awkward relationship.

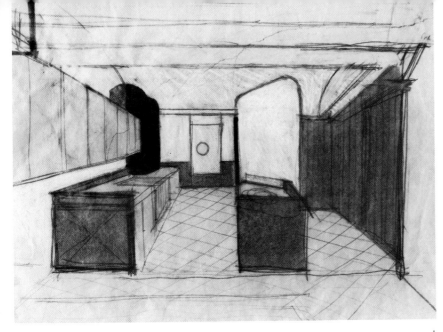

A pencil perspective with color tones added on yellow tracing paper depicting a residential kitchen (Norman Diekman, designer).

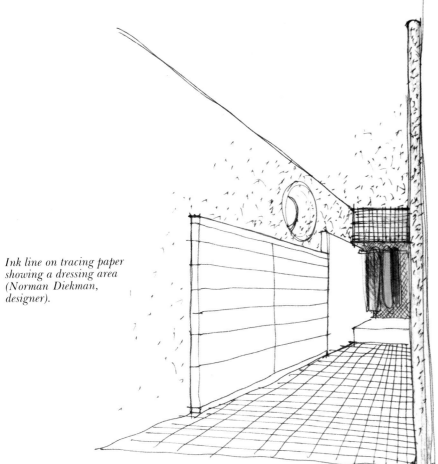

Ink line on tracing paper showing a dressing area (Norman Diekman, designer).

A corner of a living room by Josef Hoffmann as shown in Ver Sacrum 1898–1903. Like Olbrich's, this drawing is clearly influenced by the Japanese wood-block print tradition. Observe the enclosing border line and the signature monogram.

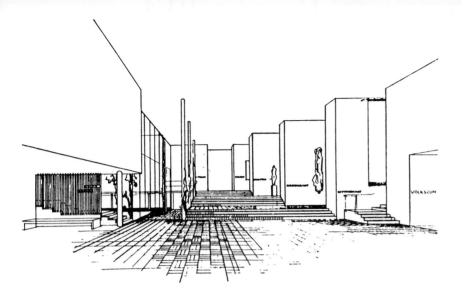

Alvar Aalto sketch combining freehand and ruled lines made over a constructed layout. Part of a competition entry of 1936 for an art museum at Tallinn, Estonia. The entrance hall is illustrated.

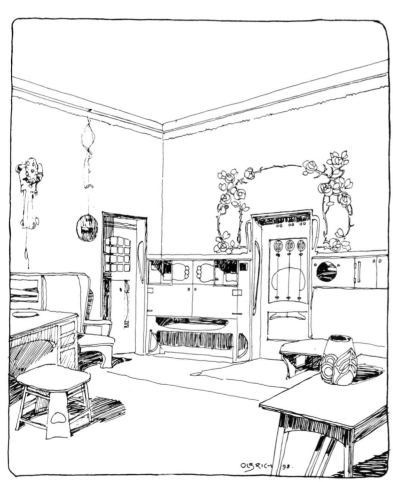

Joseph Olbrich, sketch for Frau Johanna Friedmann's room in the Villa Friedmann at Hinterbrühl near Vienna (1898). This ink line drawing was probably made over a constructed layout. The influence of the Japanese print on Vienna Secessionists can be noted (courtesy of Academy Editions, London; reproduced from Olbrich by Ian Latham.)

Right:
Drafted scale plan and ink line sketch made over constructed layout. The project was a proposed renovation of a customer service lobby in the Metropolitan Life Insurance Company New York headquarters. Color was added to prints for presentation. (Design and drawing by John Pile for Sandgren and Murtha, Industrial Designers.)

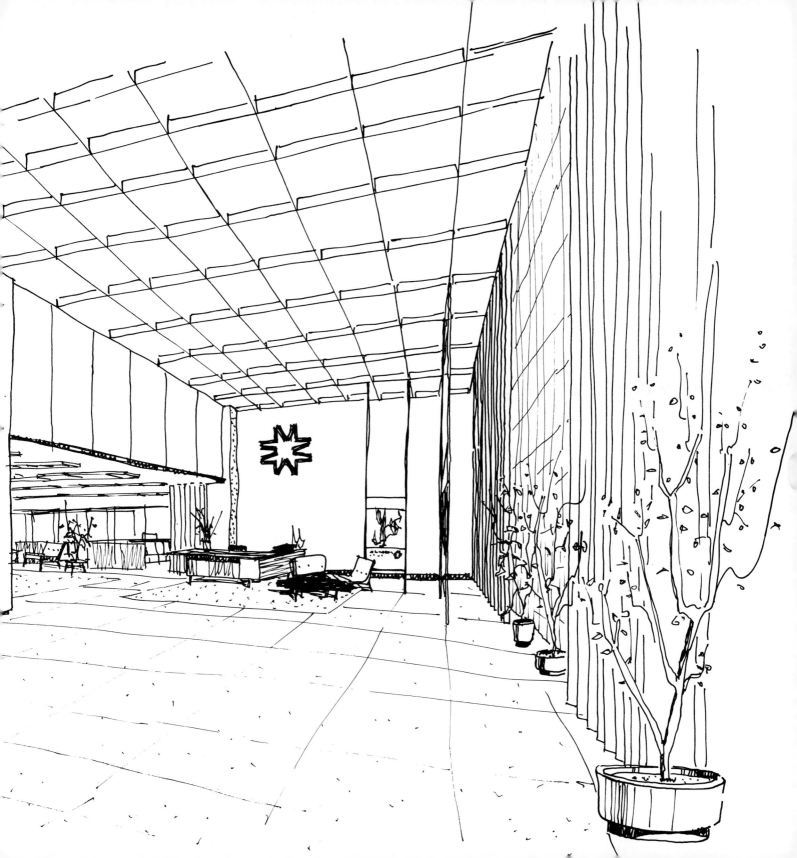

FREELY CONTRUCTED PERSPECTIVE

A technique that falls somewhere between drawing from life and a traced construction might be called "freely constructed" perspective. This involves the use of horizon and vanishing points, possibly even a revolved plan with station point, but all of these construction elements are drawn freehand rather than with instruments.

When working in this way, begin by drawing a horizon and a height line. For a one-point view, the back wall of the space is drawn as a freehand elevation. One vanishing point is placed (or, for a two-point view, two vanishing points are placed) well to the right and left of the height line. The "box" representing the space is then drawn, freehand, with lines radiating from the vanishing points positioned by eye. A straightedge can, of course, be used as an aid in getting key lines in place accurately.

"THUMBNAIL" PERSPECTIVE

A useful variation on the freely constructed perspective method involves making a miniature or "thumbnail" layout, drawn freely, but with rotated plan, picture plane, horizon, and vanishing points. A number of trials can be made very quickly in order to arrive at a basic layout that will generate a desired view. The thumbnail is then set up as a reference and "copied" to form the basis of a larger and more carefully drawn final sketch.

Working in this way on paper will help the designer to develop the experience that will eventually make it possible to do "thumbnail layouts" entirely in the mind so that a fully free drawing can be drawn directly on a final sheet, as if from life. The ability to draw a satisfactory perspective, using only the mental image as a guide, is very useful to any designer in developing conceptual sketches and in providing illustrations for discussions with clients. Laymen are always impressed and pleased to watch sketches that illustrate believable space, furniture, or other elements appear on the spur of the moment from the hand of the designer—it is a most convincing evidence of skill.

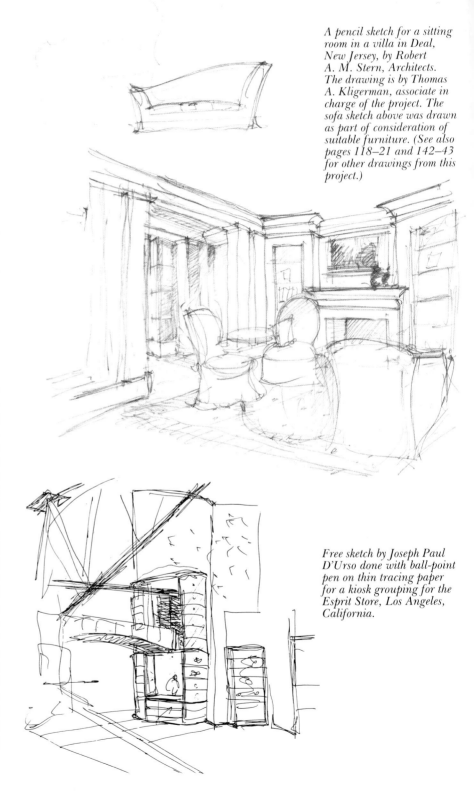

A pencil sketch for a sitting room in a villa in Deal, New Jersey, by Robert A. M. Stern, Architects. The drawing is by Thomas A. Kligerman, associate in charge of the project. The sofa sketch above was drawn as part of consideration of suitable furniture. (See also pages 118–21 and 142–43 for other drawings from this project.)

Free sketch by Joseph Paul D'Urso done with ball-point pen on thin tracing paper for a kiosk grouping for the Esprit Store, Los Angeles, California.

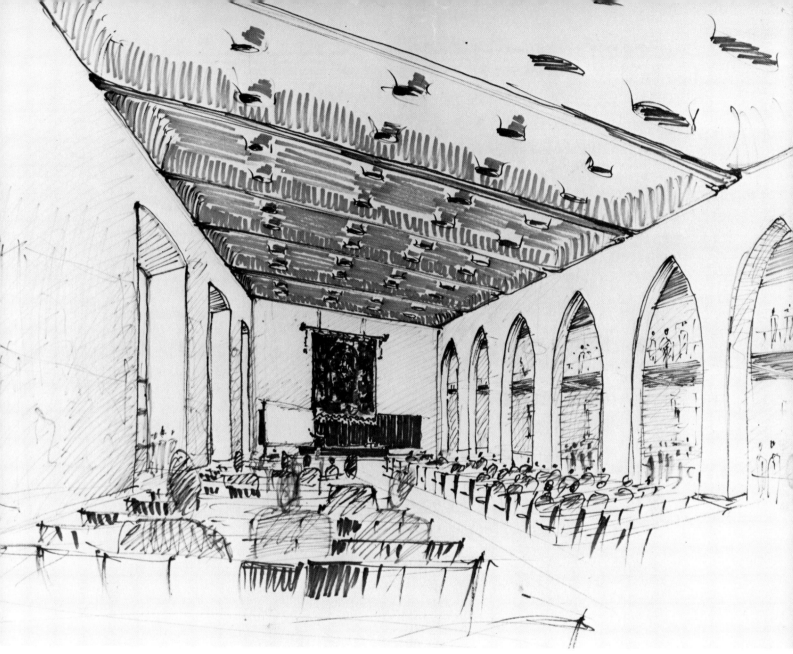

*Studio Architetti BBPR
(Banfi, Belgiojoso, Per-
essutti, and Rogers). A
large, freely drawn sketch
for an auditorium-confer-
ence room in the remodeled
Castello Sforzesco, Milan
(circa 1963). The drawing
is in soft pencil with a few
areas of color added with
broad felt-marker pen.*

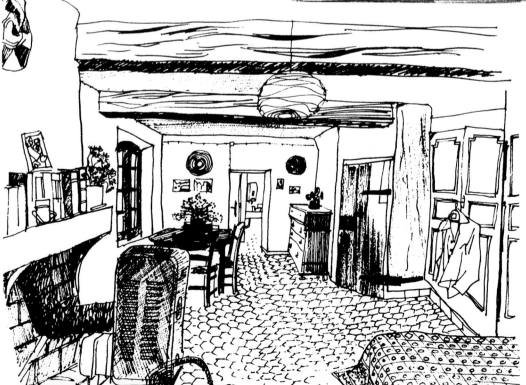

Above:
A small sketch and a more developed sketch for the interior of the "Epicyclarium." Black colored pencil on tracing paper, preliminary to a more finished rendering. (Sketches and design by Lebbeus Woods, architect.)

A free sketch in ink by Irving Harper. This was done on site on a sketchbook page in a room of a Provençale house in southern France.

RESPECT FOR BASICS

Whatever mix or balance of freehand and geometrically constructed drawing is chosen, convincing results always depend on an understanding and respect for the geometric rules that govern perspective. Odd and disturbing results produced by beginners can usually be explained by tracking down some error in perspective construction. The following checklist may be useful in "trouble-shooting" a problem drawing.

1. The horizon line must be truly horizontal and at eye level, even if it is not shown as a drawn line.

2. Lines that are parallel in actuality must angle toward a particular vanishing point. The only exception is one set of parallels in a one-point view; these must be accurately horizontal. Vanishing points for horizontal lines must be on the horizon. Use of two vanishing points that are not both on the same horizon level is a common cause of oddly twisted furniture images.

3. All verticals must be truly vertical, unless a three-point perspective is being attempted. In that case, all verticals must be angled toward a common vanishing point far above or below the horizon.

4. Circles or parts of circles must be shown as true ellipses or parts of ellipses with major and minor axes correctly oriented. In particular, circles in a horizontal plane must have a horizontal major and vertical minor axis. Ellipses never come to a point, no matter how "flat" they may be. Try to avoid placing any circular element exactly at eye level where it will appear as a straight line.

5. Respect a reasonable cone-of-vision angle. Carrying elements in a perspective too far forward or too far to either side will introduce effects of distortion, even if the drawing is accurate.

It should also be mentioned that in freehand drawing one is free to break any of the rules of "correct" perspective drawing at will to get an expressive effect. Modern artists often take liberties in introducing deliberate distortions in perspective. In representing architectural interiors, however, designers are usually more concerned with accuracy than with whatever emotional impact such distortions may have. Nevertheless, there are no unbreakable rules about what can and cannot be done. It is important that if geometric rules are to be broken for effect, they should be broken *knowingly* and for clear purposes. When the rules of perspective drawing are broken through carelessness or error, the result is not expressive but simply unsatisfactory.

Perspective with the Camera

THE DEVELOPMENT of lenses and the subsequent invention of photography have provided artists and designers with a way to generate geometrically accurate perspective images with great ease. It was once thought that photography would make perspective drawing (and many aspects of the arts) obsolete. No matter how useful photography may have become in providing accurate images of reality, it cannot supplant drawing as a way of illustrating plans and proposals. The designer is still dependent on drawing until projects are actually constructed—when the architectural photographer can take over the creation of images.

Photography, or at least its key instrument, the camera, can be a useful device in the study of perspective—without even taking a picture—if the viewing system of the camera used is adequate. The lens of the camera acts as a "station point" in making a perspective that is projected on the film surface, which acts as a "picture plane." All of the effects that are developed in constructed perspective drawings can be demonstrated with camera manipulation, and the camera image is always detailed and impressively accurate. Since the camera is so commonly used today, some suggestions are offered here about how the camera can be used to develop fluency in perspective drawing. Actually taking demonstration pictures will generate a record of the effects observed,* but even a camera without film will serve very well to demonstrate these effects.

"Snap-shot" cameras with a peep-sight viewfinder and older box and folding cameras do not provide very satisfactory viewing for our purposes. Any camera with arrangements for ground glass viewing will serve well. Field and view cameras of the sort that provide a ground glass back viewed under a black cloth, although much used by architectural photographers, are also not ideal for perspective study. First, they must be set up on a tripod; second, the black cloth is a bit of a nuisance; third, but most important, the im-

*Any Polaroid camera or Polaroid 35mm kit used with any 35mm camera makes it possible to obtain results virtually instantaneously.

age on the ground glass is both dim and upside down! Fortunately, the most popular of modern cameras are reflex instruments providing a clear ground glass image, right side up and visible when the camera is hand held.

Larger single- and twin-lens reflex cameras (such as the popular Rolleiflex or Hasselblad) provide a bright image which is, however, reversed, right to left. The *most* popular of modern 35mm cameras, the single-lens reflex cameras (Nikon, Pentax, et al.) use a prism that provides an image upright, correctly oriented, and viewed while looking straight toward the subject field of view. Any such camera is ideal for observing perspective effects.

The "normal" lens usually provided with a camera takes in an angle of view (cone of vision) of about 45° in the horizontal direction. The wider angle of vision usually desired in interior perspective drawing is provided by wide-angle lenses. A 35mm lens includes an angle of about 60°, a 25mm lens about 80°. This is about as wide an angle as is usable without noticeable distortion near the edges of the image. Any lens will demonstrate perspective effects, but a wide-angle lens will make these effects more striking.

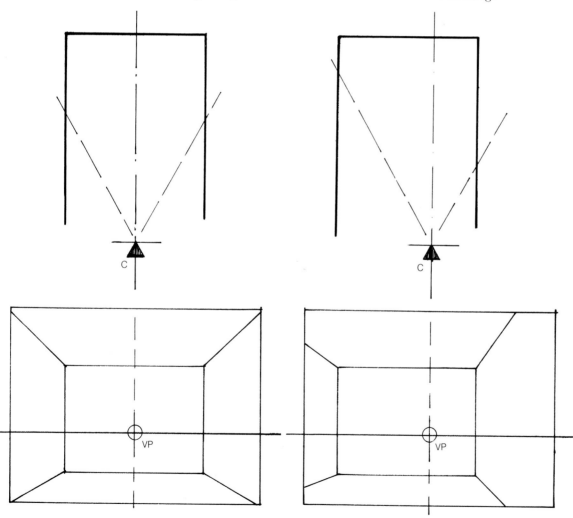

Far left:
Camera placed at center line of space.

Left:
Camera shifted to right of center.

OBSERVING THE PERSPECTIVE

The convention accepted in most architectural drawing, that all vertical lines must appear truly vertical, requires that the camera be held level. Assuring this is easiest if the camera is placed on a table or other support; a tripod with a convenient height adjustment is best of all. Tilting a camera up or down results in many amateurish architectural pictures in which buildings lean backward distressingly. Architectural photographers use view cameras with complex "movements" or PC (perspective correction) lenses to avoid this effect, but a level camera avoids the problem and will solve most other problems in producing interior imagery, where great heights are not ordinarily involved.

With a camera set up level in any convenient interior, it is possible to observe the behavior of the key lines in each type of perspective. If the camera is lined up with its center line accurately parallel with side walls, a one-point perspective will be seen, with the end wall appearing in "elevation." The one vanishing point will be directly ahead of the camera, centered if the camera is at the center of the space, shifted to right or left to match the camera position.*

If, while keeping the camera level, it is angled to right or left, a two-point perspective will appear. The vanishing points can be located by carrying lines to their point of convergence, which may be within the field of view or outside it. This can be verified in a print where the vanishing points can be marked. Vanishing points will be found to lie on a horizon that will be at the exact height of the camera.

It is interesting to observe the gradual change in the angle of horizontals as the camera is turned from the one-point position in which the end wall horizontals appear horizontal. A slight turn will make these lines angle very slightly toward a remote second vanishing point. As the camera is turned further, the vanishing point moves closer, and the horizontals will angle more sharply up (below eye level) or down (above eye level).

Moving backward or forward in space will bring about the changes that result from moving the station point backward or forward in plan. In many interiors it will be found that there is hardly enough room to move back far enough to include a satisfactory view. If a wide-angle lens is available, substitute it for the normal lens. This will make it possible to see a wider angle of view and to explore more striking perspective effects. This explains the popularity of wide-angle lenses in interior architectural photography and the use of a wider cone of vision in perspective drawing. "Extreme" wide-angle lenses generate unusual effects, but they may introduce distortion at the edges and corners of the image, just as these problems appear in drawings with an extreme cone of vision. The draftsman has the option of moving the station point back as far as may be desired, even back through walls or obstructions. Obviously, the person looking through a camera cannot do this, unless a convenient door or window makes a further move back possible.

The effect of changes in eye level can be observed by moving the camera up or down (always keeping it exactly level). An "elevator" tripod may be convenient, or one can use a step stool or ladder for observing high eye-level positions. It will be observed that the horizon level moves up or down with camera position, with the vanishing point always remaining on the horizon. The angles of perspective lines will change accordingly.

Finally, try tilting the camera up or down; a three-point perspective will appear with vertical lines tilting toward a vanishing point far above or below—an effect usually avoided in drawings. The "rising front" of a view camera or vertical adjustment of a PC lens make it possible to include an upward or downward view without tilting the camera, within certain limits. The draftsman can achieve the same result by simply continuing a drawing upward or downward as far as desired and can include as much or as little foreground as desired at will.

*A PC lens or the "shifts" of a view camera can place the vanishing point as desired, centered with the camera located off center or shifted to right or left with the camera centered.

A "normal" lens establishes a cone of vision that may be too narrow to give a satis-factory interior view.

A wide-angle lens includes a wider cone of vision but may produce forms that seem distorted near edges and corners.

A one-point perspective with the camera leveled and centered produces a perspective with the single vanishing point centered.

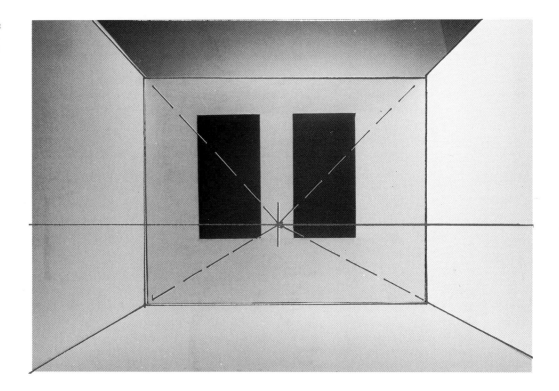

With the camera still level but moved to one side, the film plane must remain parallel with the far wall to produce a one-point view with the vanishing point off center.

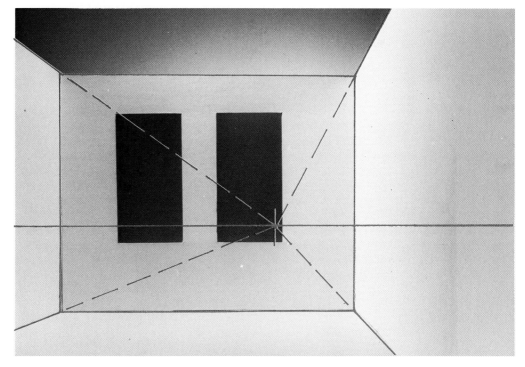

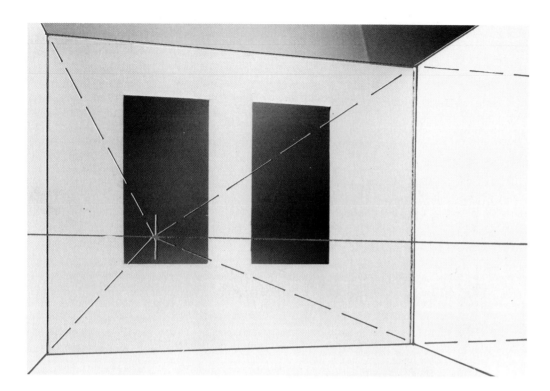

Moving the camera close in results in the same effect as a closely placed station point in making a drawing.

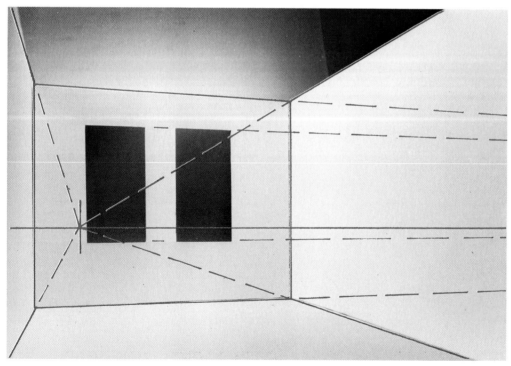

With the camera (or station point) moved back, a wider view can be included. In a drawing, this is always possible, but a camera can move no farther back than the actual space will permit.

Raising the camera above normal eye level reduces foreground and permits inclusion of additional upper portion of space without tilting verticals. If the camera cannot be raised, a "rising front" of a view camera or a perspective correction (PC) lens can give a similar result.

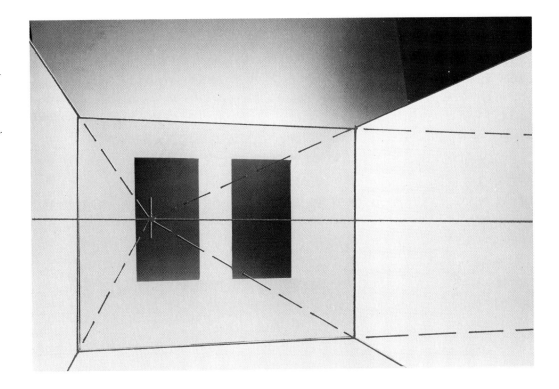

In contrast, a low camera position (like a low station point) emphasizes foreground and reduces visible ceiling. A view camera "drop front" or a PC lens can produce a similar effect from normal eye level.

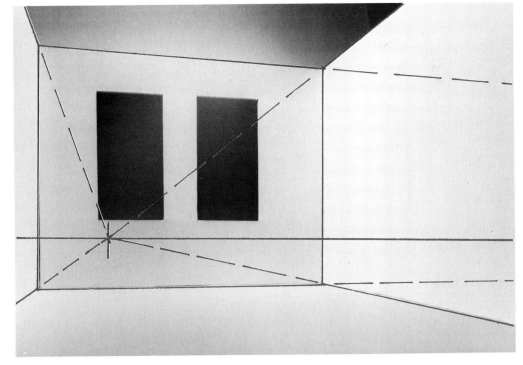

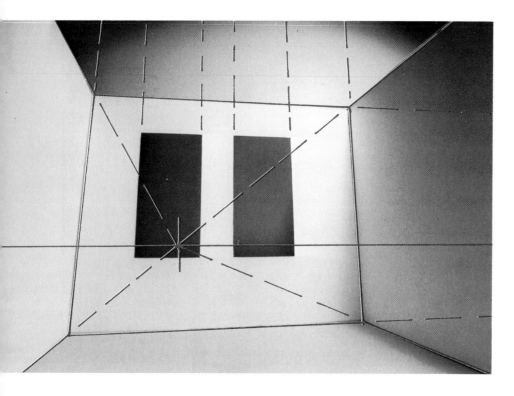

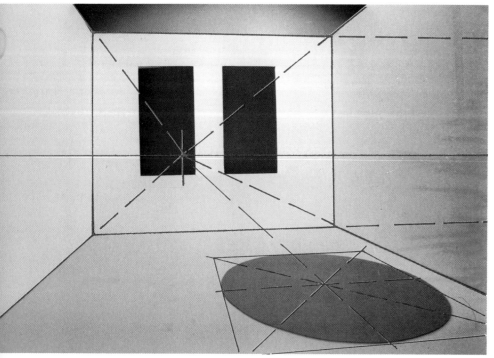

HOW CIRCLES APPEAR

The camera is also useful for observing the appearance of circles seen in perspective. It may not be easy to find a room with major circular architectural elements, but smaller circular objects can serve to demonstrate the key effects. A round table or, when viewed close up, plates, cups, or bowls will serve. Note the ellipse form and the gradual change from rounded to flattened as the circle in a horizontal plane is brought upward to camera level. Notice that the rules about ellipses in a horizontal plane apply as long as the circle viewed is near the center of the image. A circle moved to a corner, particularly if viewed with a wide-angle or "super-wide" lens will show distortion, just as circles constructed with the grid-of-squares method will when placed in similar locations.

Circles in a vertical plane can often be found in such forms as round mirrors or clock faces or can be produced for the sake of experiment by cutting out discs of paper or cardboard to be taped up where they can be viewed from various camera angles. Out doors, finding an arcade of actual semicircular arches makes it possible to study these circular forms in various camera-to-subject relationships.

Actually taking photographs that demonstrate various perspective relationships is a natural next step. With prints enlarged to a convenient size, a sheet of tracing paper can be used to develop a drawn layout analyzing the view shown, locating horizon and vanishing points, tracing the construction of ellipses, etc. Photographs of models, useful for their effect of realism, can be the basis for analyses that can include three-point perspective, views from above, and sectional perspective—effects not usually available in real settings.

Chapter Six is concerned with analysis of perspective views in both drawing and photographic form. A number of demonstrations of graphic analysis of photographs are included there.

Top left:
A tilted camera, particularly one with a wide-angle lens, generates the leaning verticals typical of a three-point perspective.

Bottom left:
A circle in a horizontal plane when placed near the corner of the frame appears distorted, as if "running downhill." This effect is emphasized when a wide-angle lens is used.

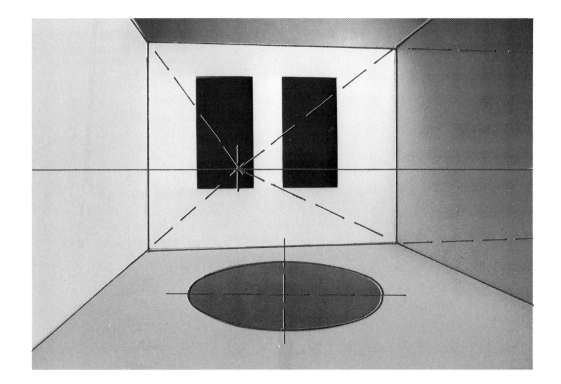

Top right:
The same circle seen distorted in the illustration on the opposite page (bottom) appears as a true ellipse when placed near the center of the field.

Bottom right:
Circles in a vertical plane will appear as true ellipses with axes positioned so that the minor axes angle toward the proper vanishing points.

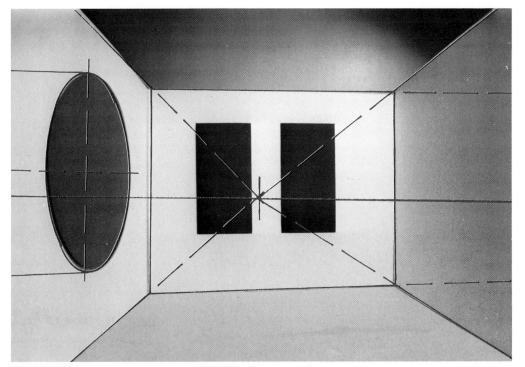

Case Studies

A FULLY RENDERED perspective drawing will usually seem complete and perfect, often filled with complex detail of almost photographic realism. It is sometimes hard to believe that such masterful end products have been generated by the simple geometric steps outlined earlier in this book. Yet this is the case. The best way to demonstrate this, of course, is to watch the process by looking over the shoulder of the draftsman at work. But this is not easy to arrange, and most records of the process have a way of vanishing. In many cases, the constructed geometric drawing is made directly on the sheet that will become the final rendering—it is simply drawn lightly with lines that are strictly for construction and erased as they cease to be needed. As final lines are drawn in, tones built up, and (in the case of rendering) colors overlayed, the original perspective plot is simply covered over.

Often a "base sheet" layout is constructed as an underlay for the final drawing, but it is likely to become a tangle of lines meaningful only to the person who has worked it up. It is not unusual to place a plan directly under (not below, but *underneath*) the layout sheet, a trick that saves space and may reduce back strain from leaning across the drawing board, but that creates a tangle of overlapping forms that will seem hopelessly confusing to an observer when looked at after the fact. "Tick strips" with locating points for a particular object or set of lines are often made, used, and then tossed away to make room for a next strip dealing with a different part of the drawing. All such work sheets (often in several layers) are usually on thin yellow tracing paper, which is chosen as much for its good transparency as for its cheapness and availability. Once the final drawing has been traced, these work sheets are usually crumpled up and tossed out.

In the case studies that follow, some of the working sheets were retained. This has made it possible to see the steps taken in making the final drawing. This is either the result of finding, by good fortune, a situation where the construction sheet had not yet been thrown away, or finding a situation where work was in progress and the draftsman was willing to save the work sheets so that they could be reproduced here.

Everyone who draws perspectives develps a unique, personal way of working that does not exactly match any one textbook approach. Mixture of constructed techniques with free "by eye" development is commonplace. "Correct" constructed elements are changed, moved, or otherwise "faked" to whatever extent the designer feels necessary or helpful in generating a finished product that will be both basically true to life and aesthetically satisfying. For all of these reasons, no example of actual work will demonstrate the precise techniques suggested in this book. Still, an effort to follow the methodology of work adopted by a skilled delineator is very helpful in making the processes that generate handsome drawings fully understandable.

1. LEBBEUS WOODS

SERVICE

TELE-PHONE ROOM

RETAIL

LOBBY

RETAIL

TO RAMP DOWN
(TO P-1 - P-2)

Drawings by Lebbeus Woods for a project: 1111 Brickell Avenue Complex, Miami, Florida (Kohn, Pedersen, Fox, Architects; partner in charge of design, William Louie; project architect, Ming Wu).

Plan sketch perspective of atrium space (right), felt-tip pen and pencil tones.

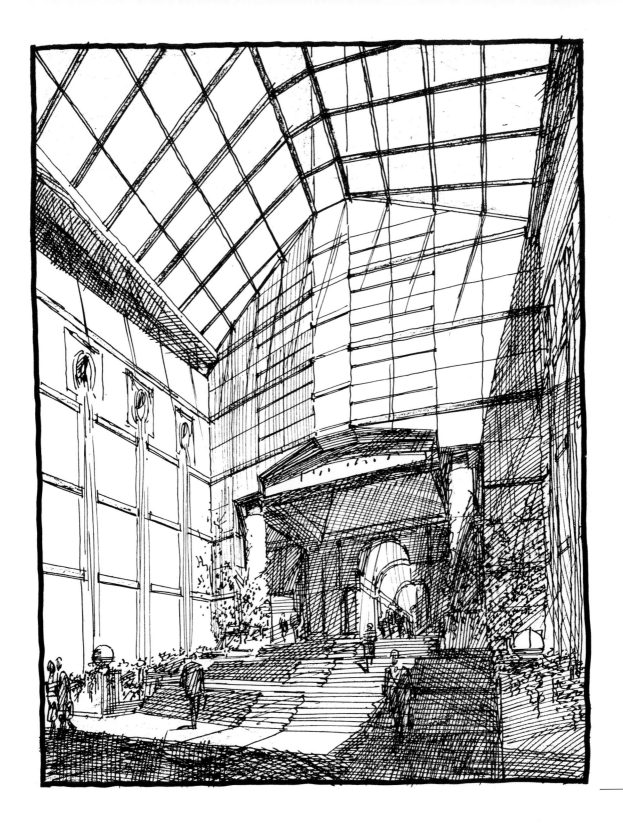

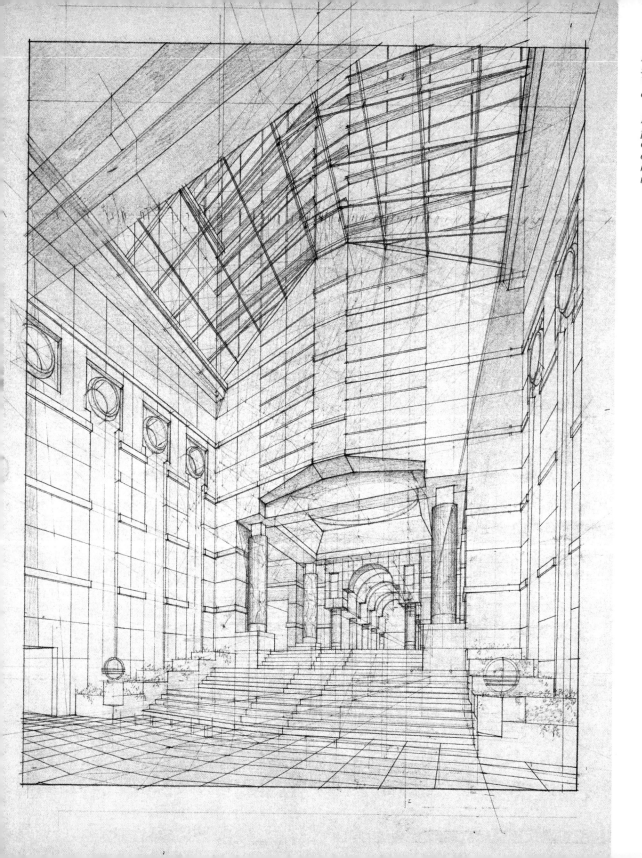

Detailed constructed perspective layout by Lebbeus Woods (see also enlarged detail, page 112).

Finished rendering, colored pencil on vellum (mounted on board). The finished drawing is in full color with highly realistic qualities of texture and light.

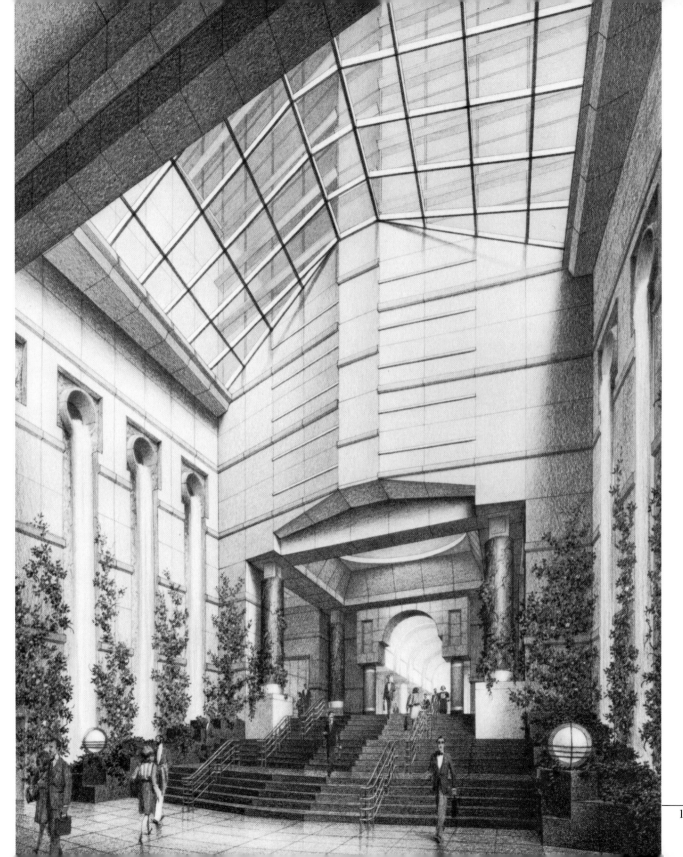

2. ROBERT A. M. STERN, ARCHITECTS

Villa in Deal, New Jersey, done by Robert A. M. Stern, Architects, New York. Thomas A. Kligerman, associate in charge.

Plan of first floor and enlarged plan of center living space.

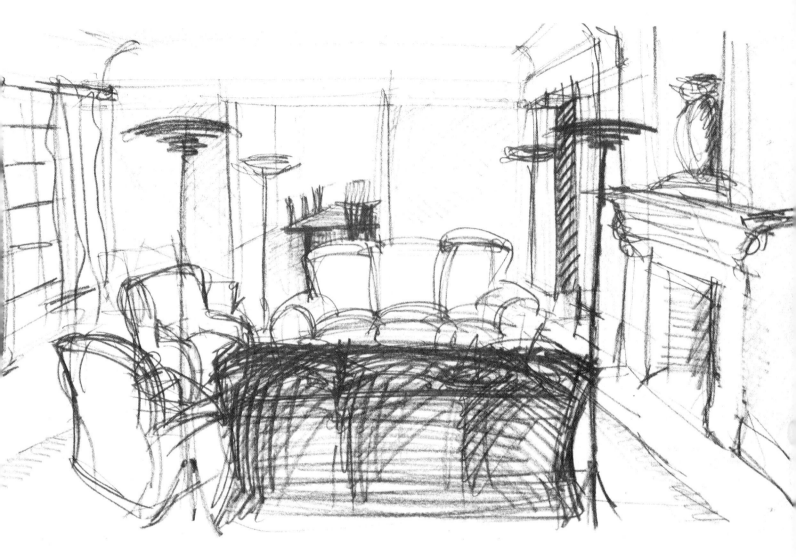

*Sketch perspective by
Thomas A. Kligerman, a
loose, freehand study.*

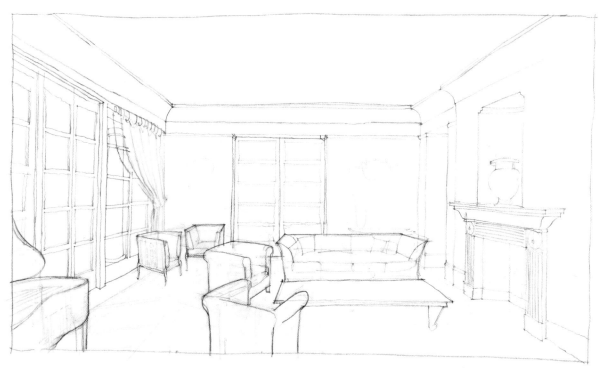

Sketch layout by Thomas A. Kligerman is the basis for several color and detail studies, including a water-color rendering by William T. Georgis. Also see pages 118–19 and 142–43 for other drawings of this project.

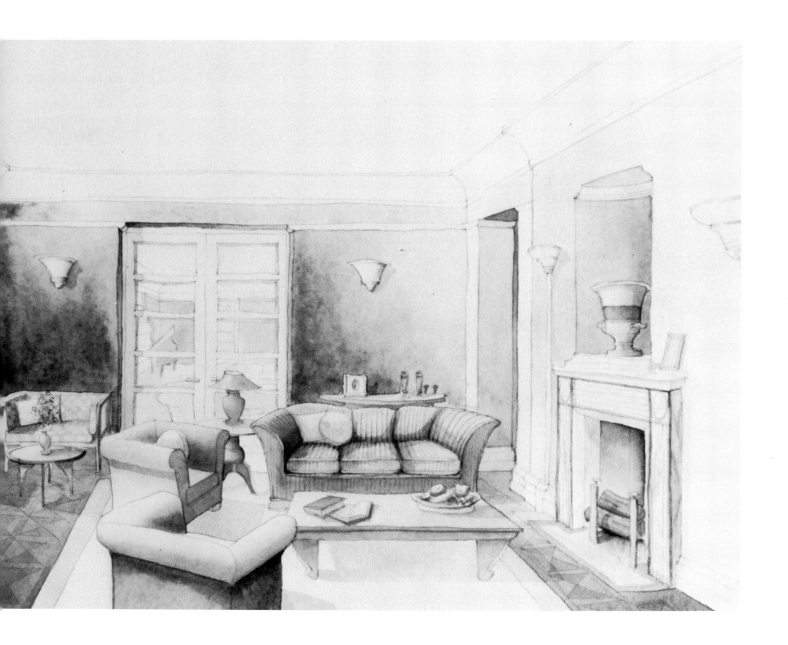

3. NORMAN DIEKMAN

Design for a furniture unit, with custom vanity and dresser developed in perspective. The adjacent bed is included to give scale and indicate a relationship. The jagged forms are granite slabs contrasting with polished wood elsewhere. The concept was developed through the sketches opposite (Norman Diekman, designer).

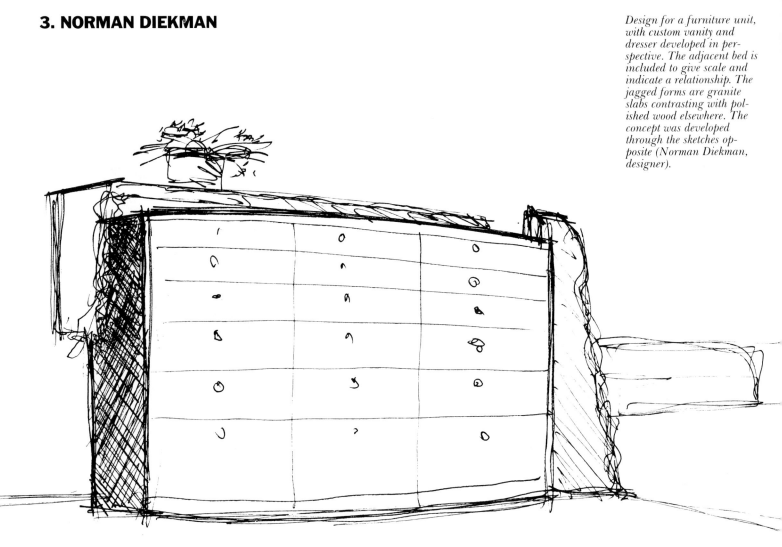

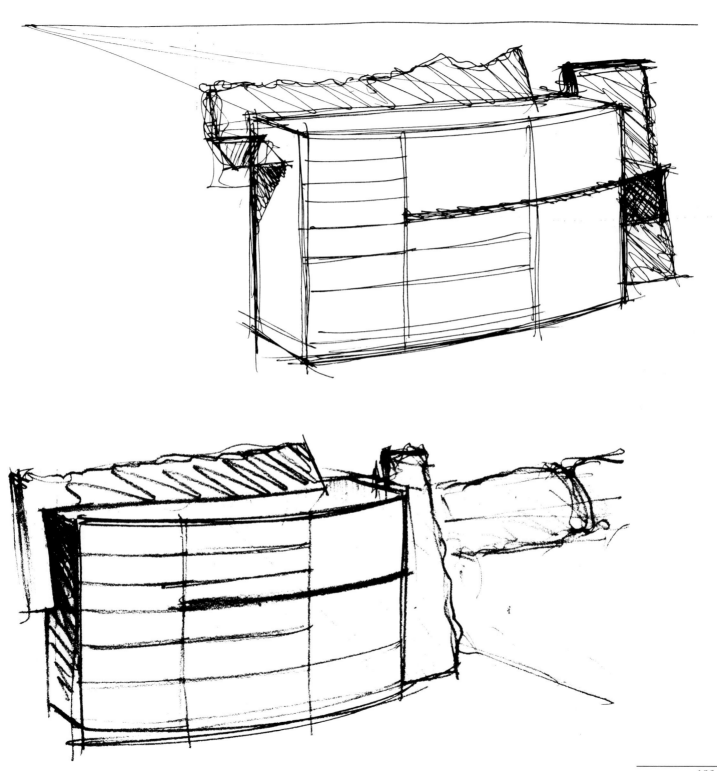

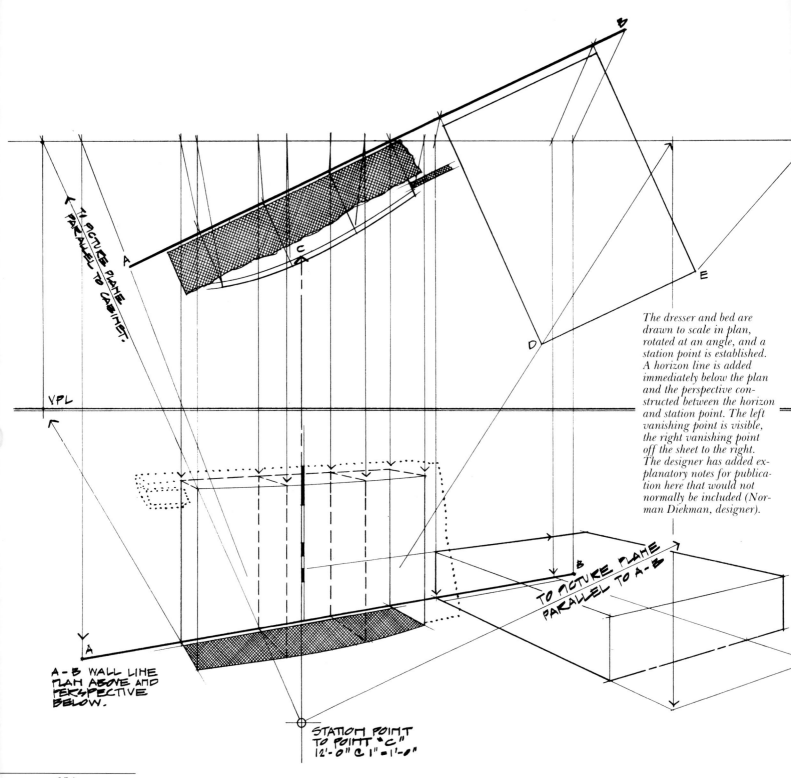

TO PICTURE PLANE
PARALLEL TO CABINET.

A

B

C

E

D

VPL

The dresser and bed are
drawn to scale in plan,
rotated at an angle, and a
station point is established.
A horizon line is added
immediately below the plan
and the perspective con-
structed between the horizon
and station point. The left
vanishing point is visible,
the right vanishing point
off the sheet to the right.
The designer has added ex-
planatory notes for publica-
tion here that would not
normally be included (Nor-
man Diekman, designer).

TO PICTURE PLANE
PARALLEL TO A-B

A

A-B WALL LINE
PLAN ABOVE AND
PERSPECTIVE
BELOW.

STATION POINT
TO POINT "C"
12'-0" @ 1" = 1'-0"

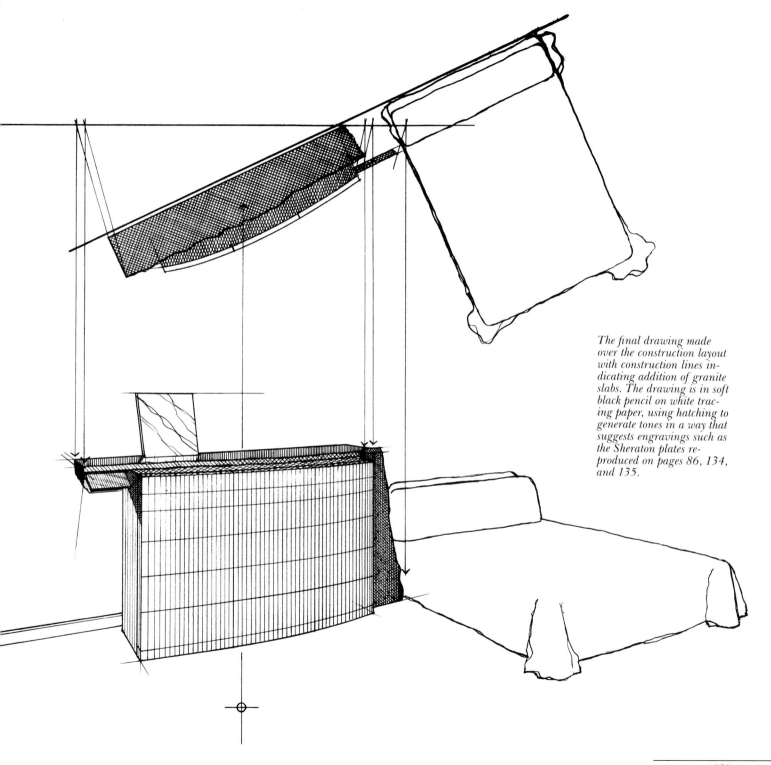

The final drawing made over the construction layout with construction lines indicating addition of granite slabs. The drawing is in soft black pencil on white tracing paper, using hatching to generate tones in a way that suggests engravings such as the Sheraton plates reproduced on pages 86, 134, and 135.

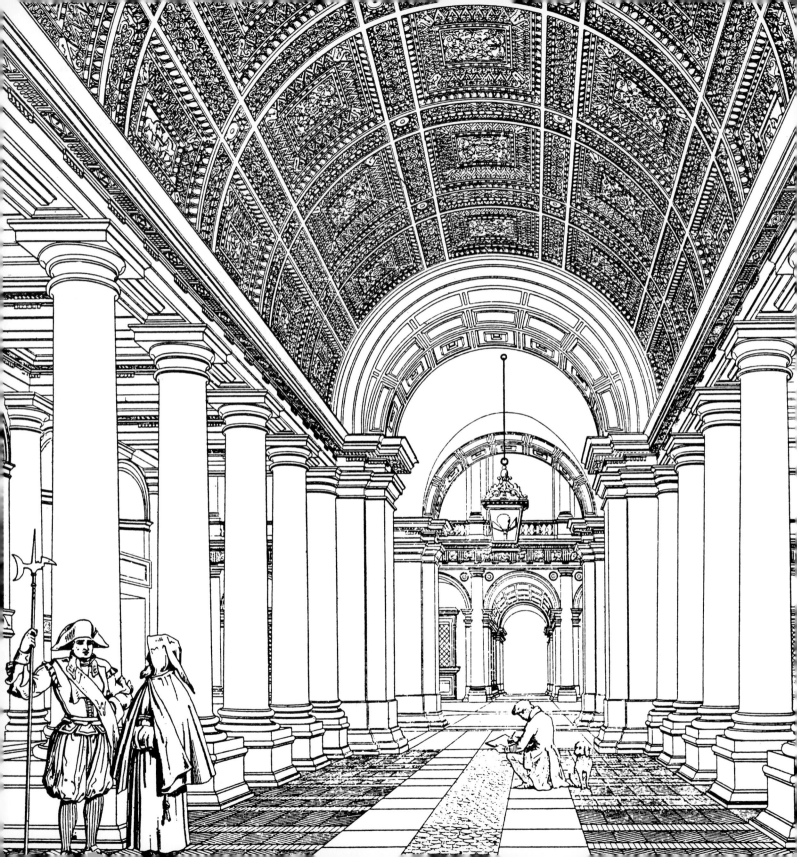

Entrance to the Farnese Palace, Rome, by Antonio Sangallo the Younger, begun 1517 (from Letarouilly's Edifice de Rome Moderne*).*

Analyses of Finished Perspectives

ONE OF THE MOST helpful ways of developing a sense of how to set up geometric construction of a perspective is to study existing drawings and photographs. In doing this, one can analyze what viewpoint was chosen, where the horizon level was placed, and how the vanishing points were located. Such an analysis can then help to suggest how comparable results can be achieved in a new drawing. Even brief observation of existing perspectives is useful, but more systematic analysis can be a very valuable way of studying perspective techniques. In this chapter, a few examples for study have been selected from various sources, old and new, drawn, engraved, and photographed for analysis. In keeping with the focus of this book, all are interiors, but the same kind of analysis can be applied to any perspective.

In studying a finished perspective, it is necessary to analyze the basis for locating vanishing points, horizon and, in plan, the station point. Once this layout data is available, a plan can be constructed and elevations generated with considerable accuracy. The purpose of this procedure is to observe the relationship of the finished view to the chosen point of view, angle of vision, and eye level chosen.

(This technique, incidentally, is also sometimes useful when there is a need for accurate drawings of a space that is not available for measurement, perhaps because it was destroyed or is inaccessible. Reconstruction of rooms destroyed by fire, damaged by war, or destroyed through mistaken renovation can be guided quite successfully by drawings produced from previous photographs or from early drawings, assuming that the latter are available. However, there are certain limitations on the precision of this technique that will become evident as the general method is outlined here.)

Analysis is done on a sheet overlaid on the perspective to be studied. It is best to work with a copy of the original to avoid indenting the original when tracing, and it is often best to enlarge or reduce the original to make it a convenient size. With some originals, where tones are very dark or where some areas are visually complex, it may be best to make a first tracing, which is a simplified line version of the perspective view. This is only necessary if the original view is difficult to see clearly through the first overlay sheet of tracing paper. The steps to follow in analyzing perspective are basically the same steps taken in making a perspective, but they are undertaken in reverse order, that is, one works backward from the image to the plan which generated it. The method varies somewhat for one- and two-point perspectives. In either case, certain estimates or guesses will have to be used in place of exact data, as will become clear from the following discussions.

TWO-POINT PERSPECTIVE

Step 1. Find lines in each of the two main sets of parallel lines for square and rectangular spaces; in more complex spaces, find lines in each system of parallels present.

Step 2. Extend two clearly identifiable lines in each system of parallels until they meet. To get the greatest possible accuracy, it is best to select lines far apart that converge sharply. The meeting points are, of course, the vanishing points of the line systems. By extending several other lines in each system, the accuracy of the vanishing points' locations can be checked. The lines that represent wall intersections with floor and ceiling would be the most usual choices of primary lines.

Step 3. Draw a line through the two major vanishing points. This is the horizon—it should turn out to be truly horizontal—which establishes the eye level used in making the perspective. Its actual height can often be estimated quite accurately. If the view seems to be taken from a normal eye level, a height of 5 feet (1.52 m) to 5 feet 6 inches (1.67 m) can be estimated. If the eye level is higher or lower than normal, its level often can be estimated by noting where the horizon passes through some object of known or easily guessed height, such as a window sill, door opening, or piece of furniture.

Step 4. (Optional at this point) A height line can be established, usually at the rear corner of the space, and a scale of heights marked off on it. This is arrived at on the basis of the eye level or, if it is known, established by the total height of the space.

Step 5. Construction of a plan can now begin. Draw a horizontal to represent the picture plane in plan. Drop the rear corner of the space (the height line) down to it, and drop the two (or more) vanishing points to it.

Step 6. Location of the station point in plan presents some problems. It will fall somewhere on a semicircle swung from a center on the plan projection of the picture plane exactly half way between the two main vanishing points. This is because the construction lines running from the station point to the vanishing points in plan make a right angle. The locus of a moving point that satisfies this condition will be found to be the semicircle described. (This can be demonstrated by placing two pins in the board spaced so that a drafting triangle can be slid against them. Following the 90° angle of the triangle as the two adjacent sides are slid along the pins will demonstrate this.) Exactly where on this semicircle the station point falls presents some uncertainty.

In the case of a photograph, provided the print has not been cropped and that the camera lens was not shifted off center, a line dropped from the center of the finished view to the semicircular construction line will locate the station point. In a drawing, a similar center line will usually give a fairly accurate location. But if the drawing has been extended farther to one side than to the other, or if it has been cropped, this location will not be quite accurate.

One way to check for accuracy is to note in the finished drawing if distortion becomes noticeable on right or left (or both) sides. Then estimate the limits of a cone of vision—the center line of the cone will intersect the semicircular locus at the station point.

A more certain way to locate the station point is possible if the finished image includes any square element in a horizontal plane. This often occurs when floor or ceiling is made up of square tiles. Identical units such as structural bays, even bricks along back or side walls can be counted off to establish a square at floor or ceiling level. Draw a diagonal of any square or squares and extend it as a construction line to the horizon. This is an auxiliary vanishing point for all such parallel 45° diagonals. Drop a construction line to the picture plane to establish the plan projection of this vanishing point. Now fit a 45° triangle between this plan projection of the auxiliary vanishing point and the plan projection of the main vanishing point on the other side of the height line. With the 45° point downward, slide the triangle along until the point touches the semicircular locus of the station point. This intersection is the exact location of the station point in plan.

Step 7. Draw lines through the station point to each plan projection of vanishing points (right and left).

Step 8. From the plan projection of the height line, draw lines parallel to the lines of Step 7. These are two walls of the space in plan.

Step 9. If a second corner of the space is visible in the perspective, locate it in plan by dropping it down to the picture plane and drawing a sight line to that point from the station point. A third wall of the space can now be drawn in plan.

All other objects and elements visible in the perspective can now be located in plan with sight lines. Elevations can be generated from the constructed plan and heights taken from the height line in the perspective.

ONE-POINT PERSPECTIVE

Step 1. Find two or more converging lines in the main (front-to-back) system of parallels.

Step 2. Extend these lines back to a point of convergence. This is the main vanishing point.

Step 3. Draw a horizontal line through the vanishing point. This is the horizon.

Step 4. A height line can be established at either corner of the back wall (or anywhere else in the back wall) wth heights estimated or fixed, as described in Step 4 for two-point analysis.

Step 5. Draw a horizontal line to act as the picture plane in plan. Drop the rear corners of the space and the vanishing point down to this line.

Step 6. The station point will be located on a vertical continued downward from the vanishing point. In this case, the problem is to decide how far back to locate the station point. This can be estimated by noting the cone of vision that establishes the right and left limits of the view. Its center line will be the vertical dropped from the vanishing point and its width, usually somewhere between 60° and 90°, can be estimated and the station point located accordingly.

As in Step 6 for two-point analysis, if squares can be found in a horizontal plane, a diagonal of the square can be used to locate an auxiliary vanishing point that will make it possible to fix an exact location for the station point. To do this, extend the diagonal to the horizon to establish the auxiliary vanishing point. The distance from the picture plane forward to the station point will equal the distance between the main and auxiliary vanishing points. This may be measured or constructed geometrically by swinging an arc with the plan projection of the main vanishing point as a center and the distance to the plan projection of the auxiliary vanishing point as a radius.

Step 7. Draw in walls and all other elements in plan by dropping lines down to the picture plane and using sight lines to locate any points needed that are forward of the picture plane.

With a basic layout set up as described, all other elements in the drawing can be studied by using some version of the methods of construction described in Chapters One and Two. Circular forms, for example, can be "boxed in" with construction lines, their centers found, and the axes of the ellipses that represent them located. Through analysis of photographs or drawings, study of difficult problems such as oblique planes, curving stairs, and reflections can be very helpful in becoming fluent in drawing similar elements when needed.

Perspective analysis is also a valuable tool for the designer in making decisions about basic layout when setting up a new drawing. If a view can be located that comes close to the desired view, whether in a drawing or photograph, it can be analyzed to determine the basic layout geometry. By working backward to locate horizon, vanishing points, station point (as nearly as possible), and angle of view, the model chosen can be converted to a new layout, complete with rotated plan and all of the other basic elements in place. Using the same or a closely similar layout for a new drawing will ensure a result that has a similar geometric character, even if the details of the space are to be totally different.

Engraving from Paul Letarouilly's **Edifices de Rome Moderne** *(1825–1860) illustrating Bramante's cloister at Santa Maria della Pace in Rome, circa 1500.*

The Letarouilly engraving is a classically beautiful two-point perspective with many semicircular arches in vertical planes in each system of parallels. Analysis begins with extending lines in each main system outward to meeting points—the vanishing points at right and left. These establish the horizon, which will pass through the eye level of the foreground figure. In plan, a picture plane location is assumed and the vanishing points placed on it. At the midpoint between the vanishing points, a center is placed to permit the swinging of the semicircular (dotted) locus of the station point.

In this engraving, the courtyard is square. The diagonal (D1) in perspective can be extended to the horizon to locate the vanishing point (VPA) for that system of parallels. Dropping VPA to the picture plane makes it possible to fit a 45° angle between VPA and VPR in plan, with its vertex on the locus of the station point; that vertex must then be the station point. Note that the center of the cone of vision established by the right- and left-hand edges of the engraving is only very slightly to the left of this location. Construction of a plan can proceed by dropping construction lines to the picture plane and leading sight lines back to the station point.

The width of the cloister passage is derived by locating center points visible in the vaulting (at A and B). These set center lines as at C in plan, and so establish the passage width and locate the outer walls. Drawing in the walls in plan demonstrates that the station point is well outside the enclosing wall so that the view is an "impossible" one on site.

Ellipses E1, E2, and E3 have minor axes angled toward VPR, while the minor axis of ellipse E4 angles toward VPL. All major axes are accurately placed at right angles to the related minor axes.

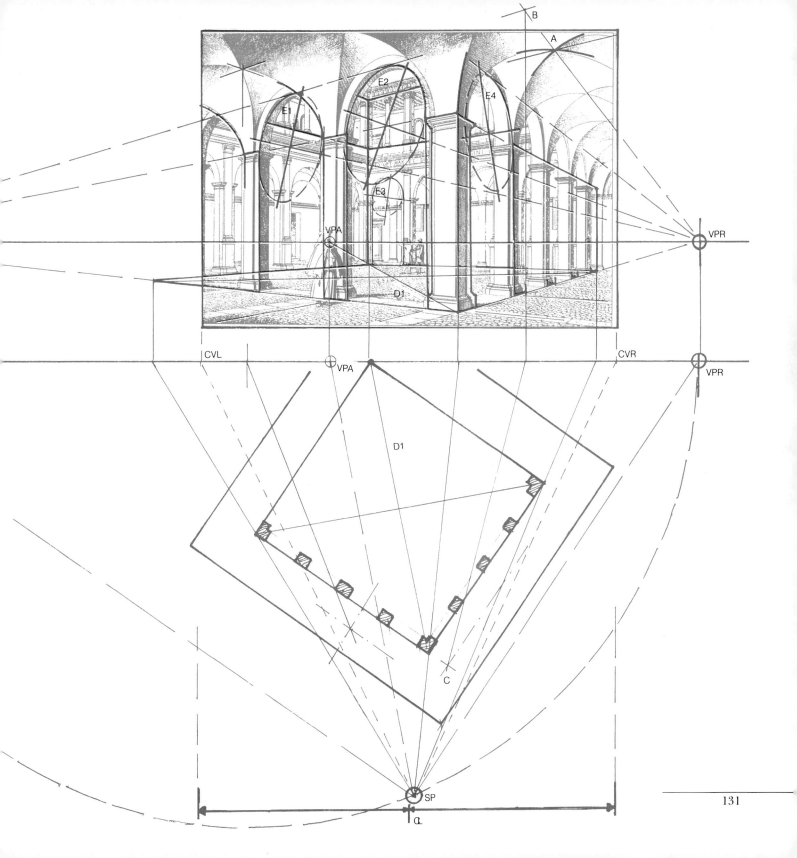

B

A

E2

E1

E4

E3

VPA

VPR

D1

CVL

VPA

CVR

VPR

D1

C

SP

α

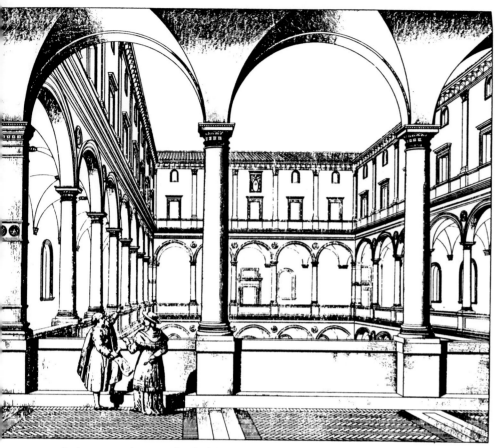

A view across the upper level of the court of the Palazzo della Cancelleria in Rome, circa 1486, of unknown authorship. The engraving is from Letarouilly's Edifices de Rome Moderne.

In the view of the Palazzo della Cancelleria, Letarouilly offers a one-point perspective, with arches in the front and back walls drawn as true semicircles and arches at the sides drawn as ellipses with horizontal minor axes (theoretically angled toward an infinitely distant vanishing point). Analysis of this engraving begins with leading lines back to the single vanishing point that establishes the horizon level. The station point must be located somewhere along a vertical dropped down from VP. How far back it should be placed is something of a problem.

A picture plane is passed through the far arcade in plan and the four arcade columns located. The right-hand side of the cloister can now be laid out in plan with columns at the same spacing. The last column visible in the engraving on the right is number four. By dropping its location down to the picture plane and leading a sight line back through the plan location of the column, the location of the station point can be determined. Using the centers of columns at A and B, diagonals D1 and D2 can be drawn. These will be found to meet on the horizon at VPA. A line parallel to D1 and D2 in plan will pass through VPA and the station point and make a 45° angle with the picture plane. This relationship can be used to locate the station point with the position of column B as a check.

Notice that the cone of vision (angle CV) is not symmetrical in this case. Also notice that the foreground column on the right and the pilaster in the left foreground have been shifted from their correct positions—the pilaster to the left by distance Y, the column to the right by distance X. This bit of "faking" opens and improves the view. Since the station point is outside the outer wall of the court, this is again a view that is impossible to obtain on site.

Notice that arches C1, C2, C3, etc., are half circles, while E1, E2, E3, E4, etc., are ellipses with horizontal minor and vertical major axes.

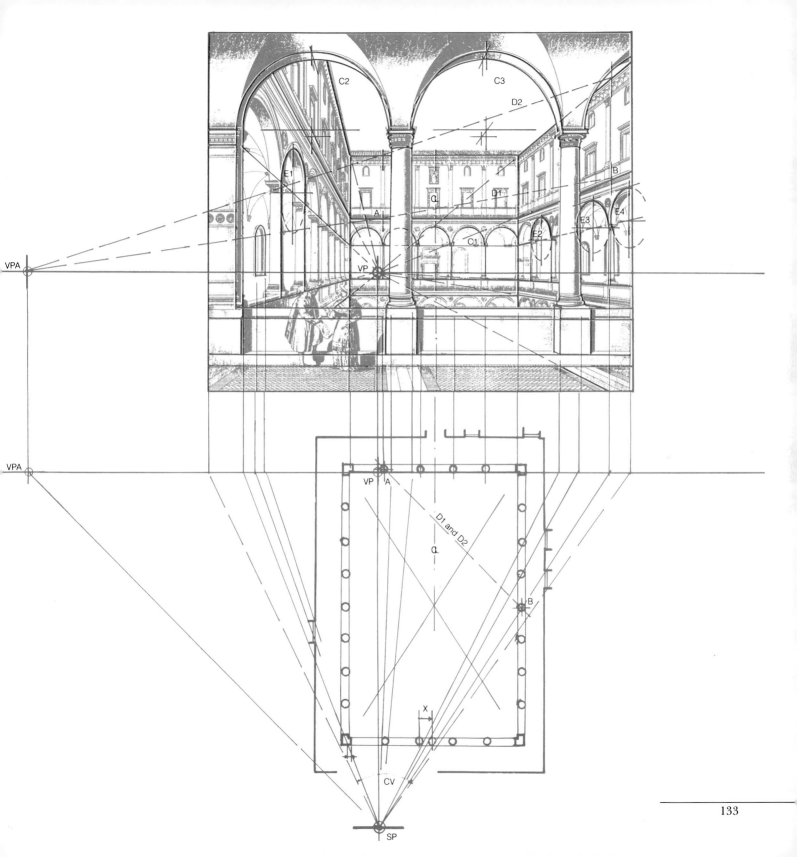

VPA

VPA

VP

C2

C3

D2

E1

B

A

D1

Q

E4

E3

C1

E2

VP

VP A

D1 and D2

Q

B

X

CV

SP

A Thomas Sheraton break-front, illustrated in a plate explaining his perspective method in The Cabinet-Maker and Upholsterer's Drawing-Book of 1792 (courtesy of Dover Publications). Sheraton's method, explained in quaint language, seems quite unintelligible, but upon analysis, the drawing can be shown to follow accurate geometric rules.

In the Sheraton work, the two vanishing points are easily found (and are shown in the original engraving). An arc swung in plan from a center between VPL and VPR establishes a locus for the station point, but its exact location is not so easily established. Trial and error locations can be used to generate rough plans until a plausible plan is found.

The station point is far to the left so that the view is actually entirely in the right-hand half of the cone of vision. The lines of the open door top and bottom angle toward an auxiliary vanishing point very far to the left. Centers are accurately placed by crossed diagonals. The axes of the ellipse for the quarter-round roll-top cheeks are suitably placed.

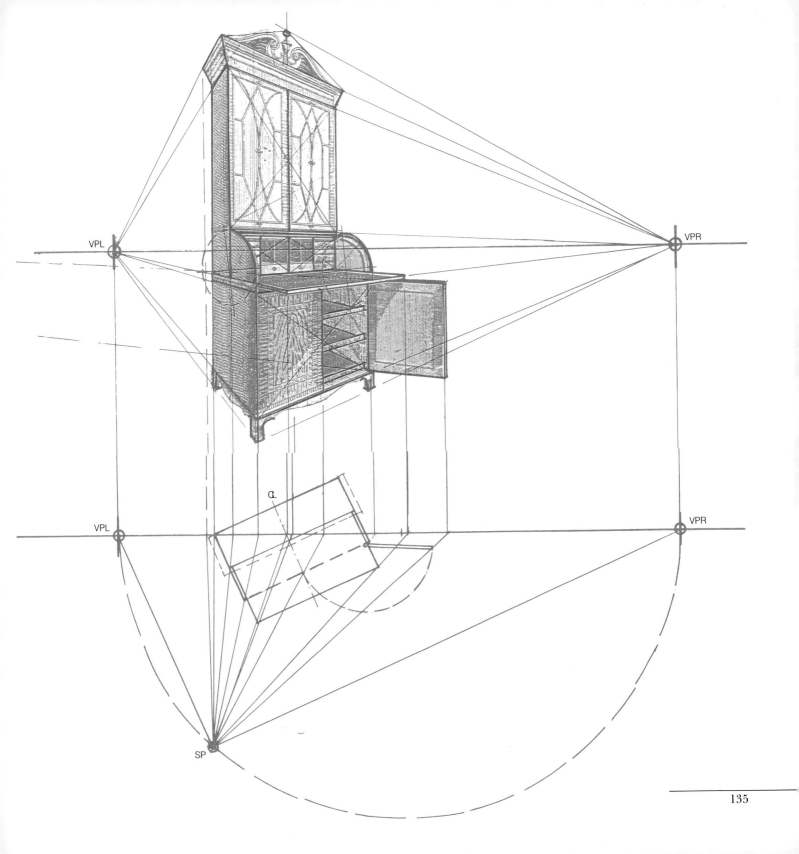

VPL

VPR

VPL

a

VPR

SP

To analyze the photograph of Pennsylvania Station, lines are extended to locate right and left vanishing points. The stairs and stair rails will be found to converge toward an auxiliary vanishing point (VPA) lying on a vertical line and running upward from VPL. The many ellipses representing arches in several planes and systems can be checked for locations of major and minor axes. Since vertical lines all appear as truly vertical and the horizon is below the center, we can conclude that the camera's rising front was put to some use.

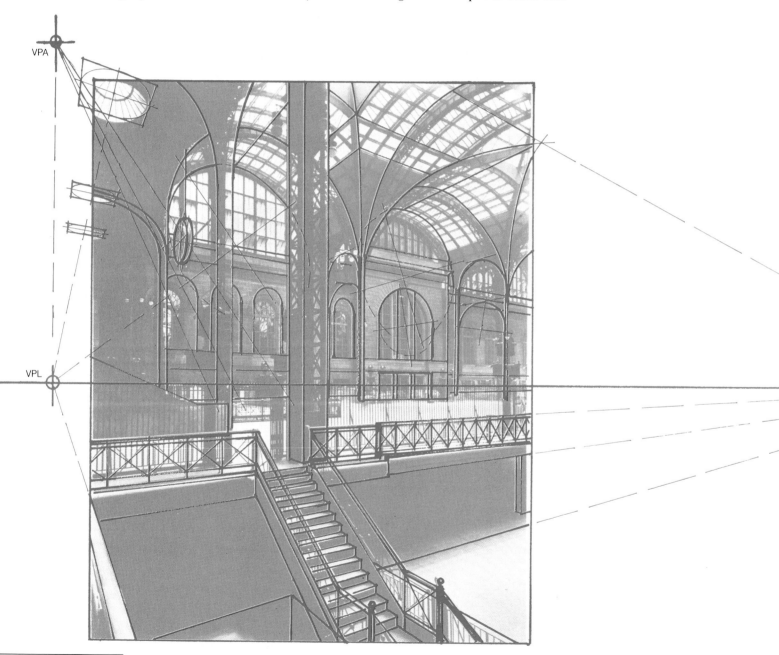

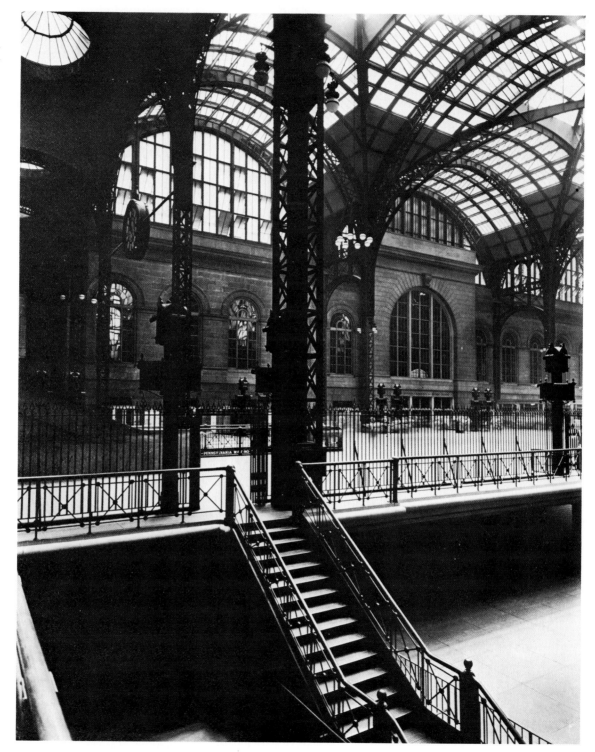

The concourse of New York's old Pennsylvania Railroad Station, a McKim, Mead, and White work of 1906–1910. Photograph of the main concourse by Berenice Abbott (courtesy of the Berenice Abbott Collection, Changing New York, Museum of the City of New York).

VPR

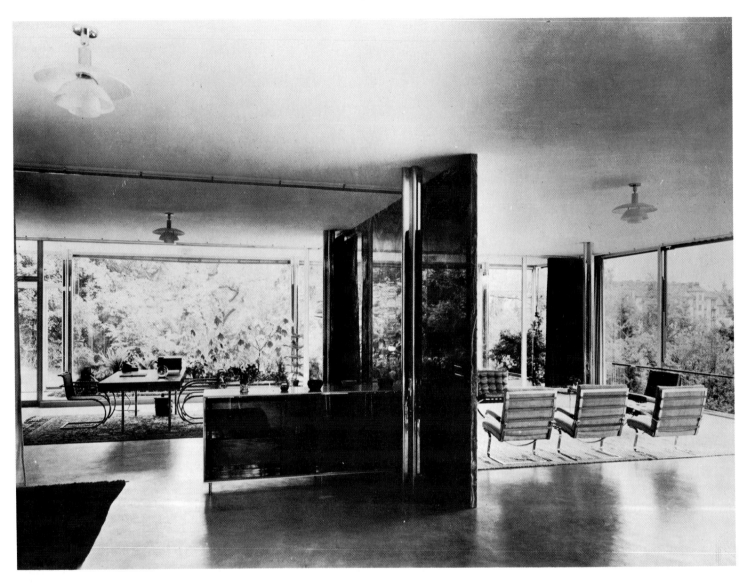

The photograph of Tugendhat House is a two-point perspective with VPL within the image and VPR far off the page to the right. By locating VPR, a center can be found halfway between VPL and VPR from which an arc can be swung in plan as a locus for a station point. In this case, using the center of the photo as an assumed center of the cone of vision makes it possible to drop a vertical to intersect the arc at SP. Placing a picture plane through the far corner of the space leads to development of a plan. Comparing the plan here with published plans of the house shows it to be quite accurate.

True verticals and a horizon below the center of the photo indicate the use of the rising front of a view camera. The 65° cone of vision suggests the use of moderate wide-angle lens.

A famous photograph of the study and living room of a famous house, the Tugendhat House of Mies van der Rohe at Brno, Czechoslovakia, 1930. (Photograph courtesy Mies van der Rohe Archive, The Museum of Modern Art, New York).

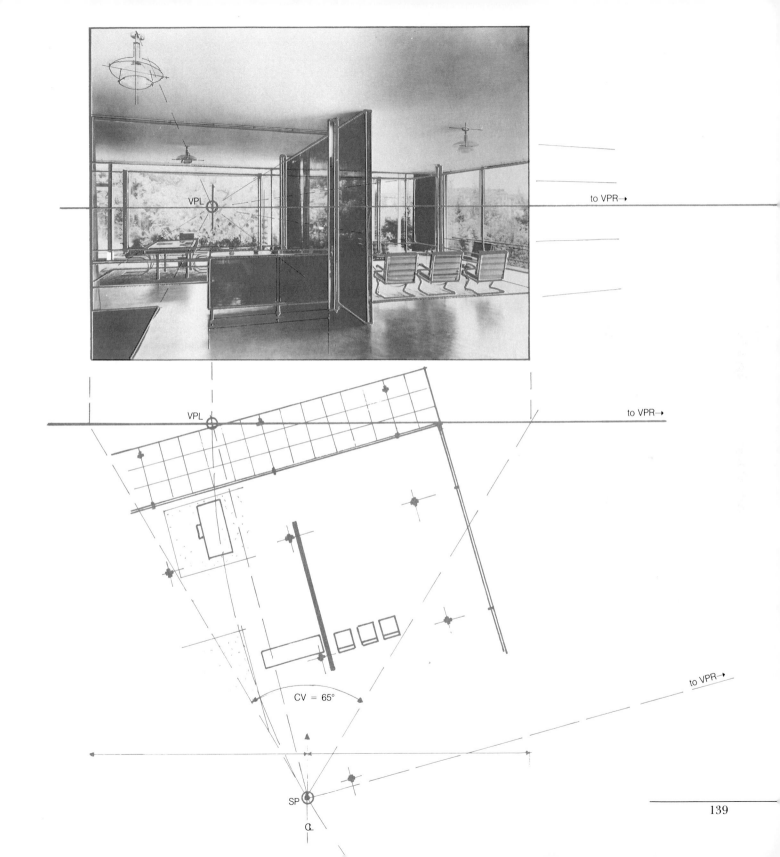

to VPR→

VPL

to VPR→

to VPR→

CV = 65°

SP

a

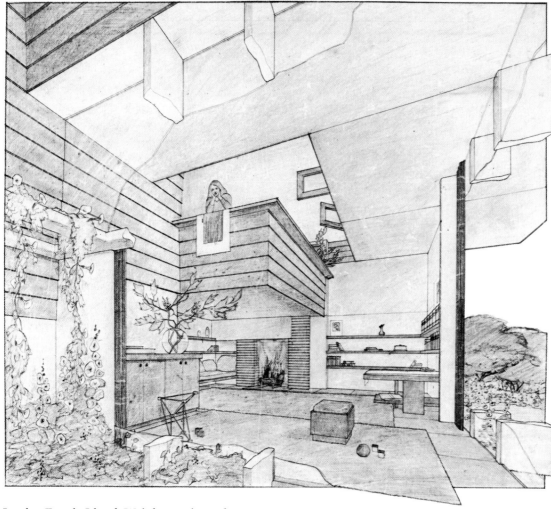

VPL

VPL

In the Frank Lloyd Wright project, the two vanishing points are found in the usual way and a semicircular arc in plan is the locus of the station point. In this case, knowing Wright's fondness for planning on a square module, it is possible to count squares and find a large square 5 by 5 modules in size. The diagonal of this square (D1) provides auxiliary vanishing point VPA. A 45° angle fitted in plan between VPA and VPR with its vertex on the locus arc locates the station point. The other diagonal of the same square (D2) angles toward a right-hand auxiliary vanishing point off the page. Its location can be checked with a construction line in plan

through the station point parallel to the diagonal and extended to the picture plane.

The plan is easily developed on the square grid and will be found to compare quite accurately with the published plan that appeared in the January 1948 issue of *Architectural Forum*. A few discrepancies between perspective and plan occur on the left at the opening under the balcony. These result from either changes made in the design or liberties taken in the interest of clarity in the drawing. For example, D2 as developed in plan does not fit in the perspective, while D2(F), the diagonal in the perspective, turns out to be false.

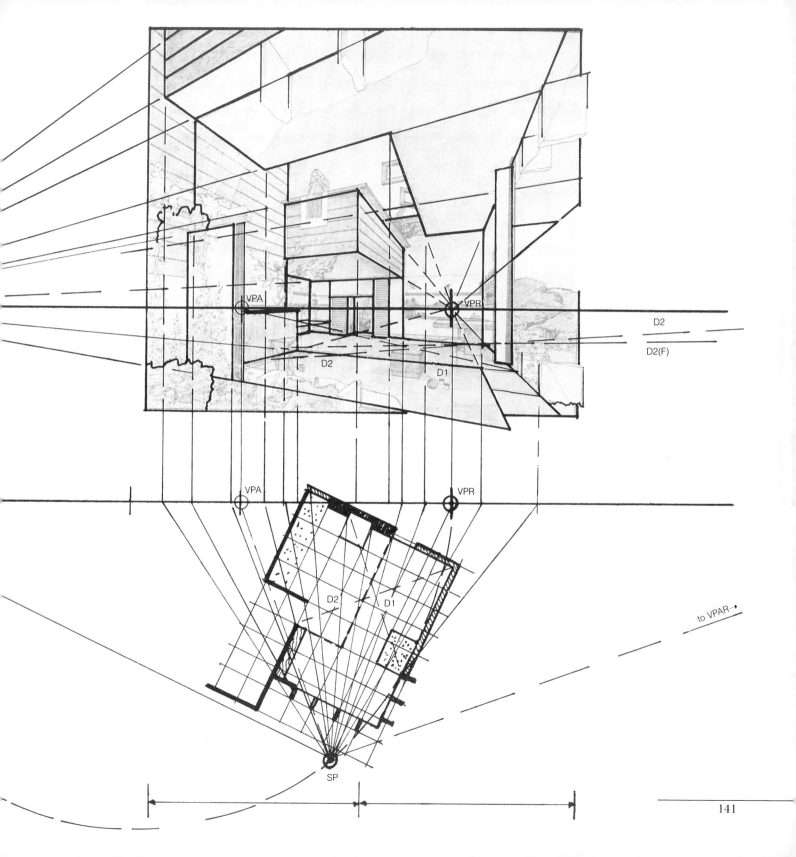

VPA

VPR

D2

D2(F)

D2

D1

VPA

VPR

to VPAR→

D2

D1

SP

A living room in a villa in New Jersey. Robert A. M. Stern, Architects, New York (Thomas A. Kligerman, associate in charge). Rendering is done in watercolor by William T. Georgis based on a sketch layout by Thomas A. Kligerman.

In this view of a living room, vanishing points are found at right and left and a station point locus arc drawn in plan. The square ceiling vault and the accurate centers established by center lines of the fireplace and the arched window make it possible to find a square at the level of the spring of the vault. Its diagonal (D1) locates VPD, which, when dropped to the picture plane, permits inserting a 45° angle between VPD and VPR with the vertex on the locus arc to locate the station point. The plan now develops easily. The angled foreground chair has its own vanishing points, VPAL and VPAR. The ellipses of the foreground floor lamp and of the arched window do not adhere to any strict rules.

142

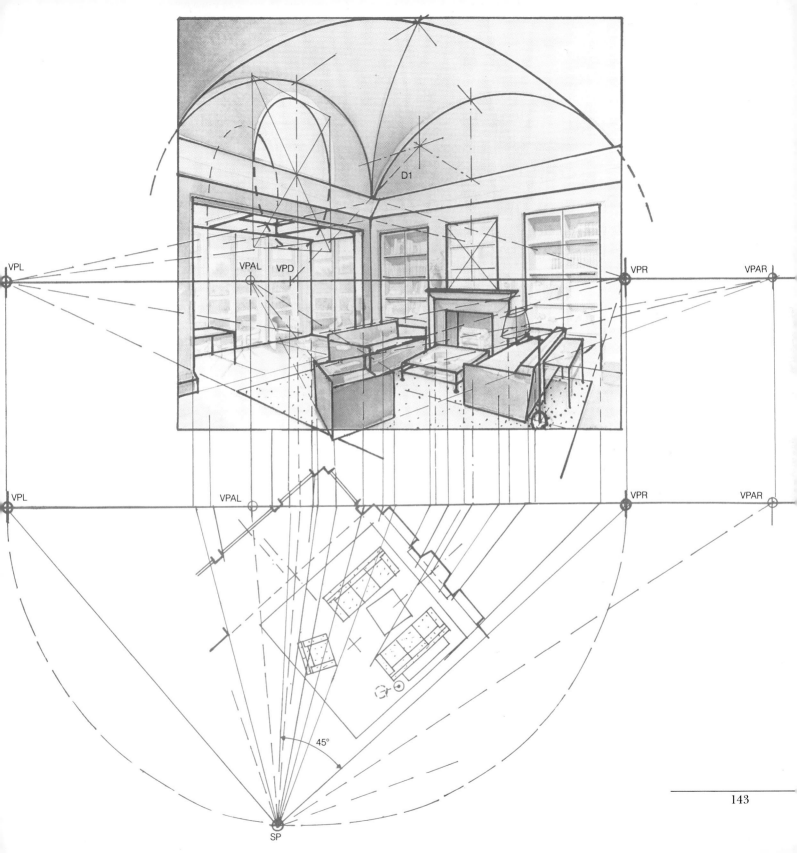

VPL

VPAL VPD

VPR

VPAR

D1

VPL

VPAL

VPR

VPAR

45°

SP

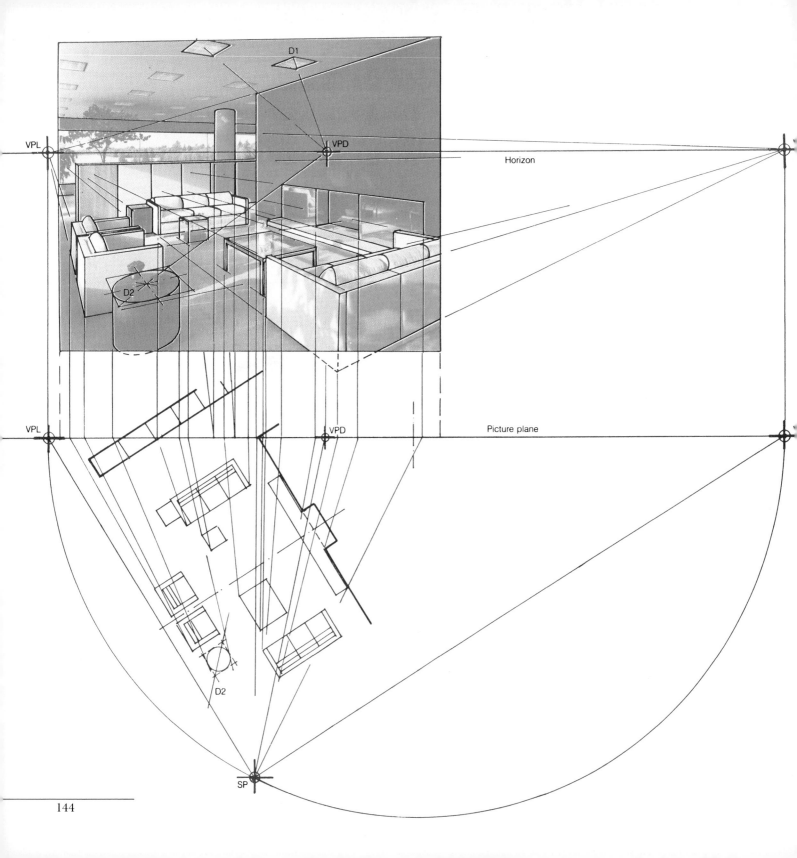

VPL

D1

VPD

Horizon

VPL

VPD

Picture plane

D2

D2

SP

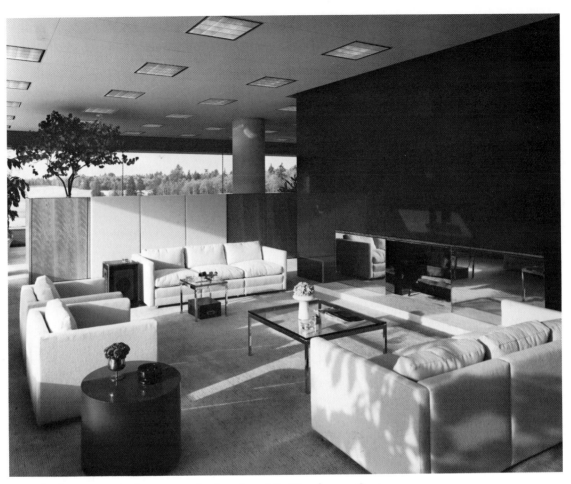

Executive lounge area in the corporate headquarters of the Weyerhaeuser Company, Tacoma, Washington, by Skidmore, Owings & Merrill, Architects.
Photograph by Ezra Stoller © ESTO (courtesy of Skidmore, Owings & Merrill).

Finding the vanishing points establishes a horizon and, since it is above the center of the photo, reveals that a view camera drop front was used to reduce ceiling and increase foreground included. In this case, the station point is placed on the locus arc by simply dropping a vertical from the center of the photo. Obtaining an auxiliary vanishing point (VPD) by use of diagonals of the square ceiling light fixtures confirms the accuracy of the station point location through the usual 45° relationship between the construction lines running from SP to VPL and VPD.

Enclosing the foreground round table in a square provides another check (diagonal D2). Notice that the axes of the table ellipses follow photographic rather than drafting logic. There isn't sufficient room to locate the distant window wall on the page, but the light fixtures set up a grid pattern that could easily be used to locate this wall and the round column.

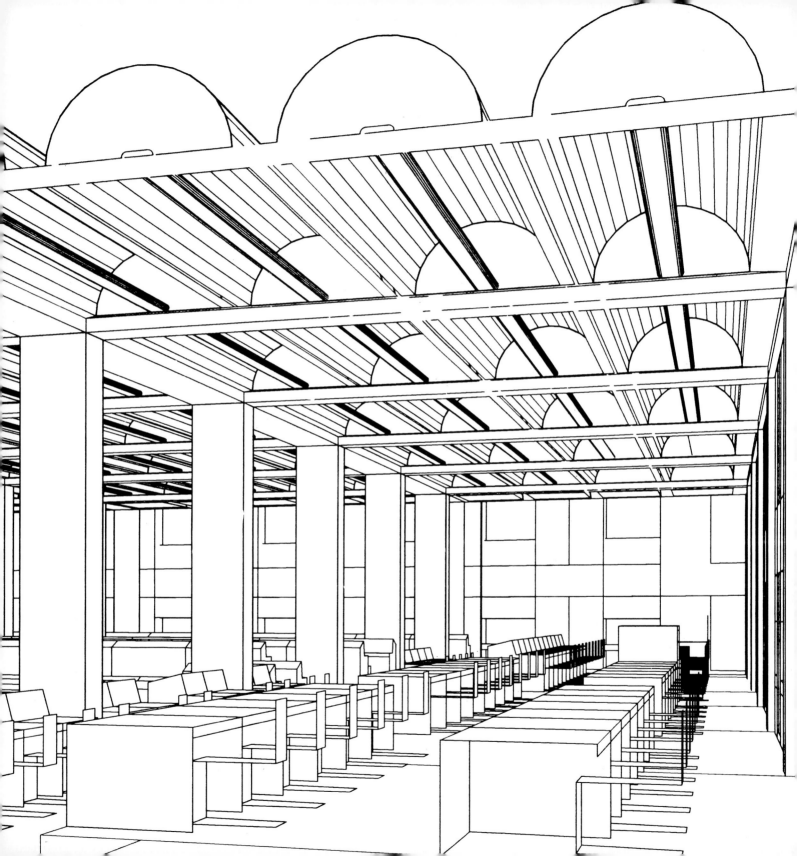

Computer-Aided Perspective Techniques

I**T IS COMMON** knowledge today in the architectural and design professions that computers can be used to make perspective drawings. The increasing availability of computers of modest size and cost has brought this equipment into use in almost every phase of human activity in the technologically advanced world. Until recently, computers were used mainly to work with such simple chores as accounting, word processing, file management, and specification writing. Even the simplest of "personal" or "home" computers can be serviceable in such work. However, "graphic capability"—the ability to create, modify, and manage images—is becoming more common today. There is a variety of "software" available that will work with a number of different types of "hardware." As a result, the computer is becoming a fairly commonplace object in the design or architectural office, almost as common as the telephone or typewriter.

Computer-aided drafting or design (know as CAD), is increasingly in use in design offices. But putting these techniques to use is not quite as simple as using a small computer to turn out letters or payrolls. For small drawings, dry reproduction techniques, such as Xerox, are highly satisfactory. However, the end products of design and drafting are often large and complex drawings. Programming these in computer memory can take fairly large computer capacity but, in many ways, it is the mechanics of final transfer to paper (or film) that is most troublesome. The machine that can do the job is a "plotter," a computer-driven mechanical device that moves a pen along a surface mechanically, much as a draftsman draws on paper. While the computer itself has been miniaturized and made reliable, even in its smallest and least expensive forms, the plotter must be as large as the drawings it is to make and is inevitably saddled with the practical problems of moving parts, flowing ink, and all the related tasks of feeding paper or film. Still, in larger offices, an expensive plotter and the staff to keep it working can become useful and economical because of the amazing speed and consistency of the work produced.

HOW CAD SYSTEMS ARE USED

The primary work of CAD systems and their related output plotters is the production of working drawings, but the existence of the equipment in design offices makes it natural to explore computer ability to produce perspectives as well. Just as orthographic projections can be viewed as exercises in plane geometry, the perspective can be viewed as an exercise in solid geometry. A suitable computer program can deal with points and lines located in relation to the classic three coordinates that are basic in descriptive geometry. With a program prepared to deal with perspective in these terms, a computer can accept data that is geometrically descriptive of any three-dimensional form. With this data in memory, any desired projection of the form can be created.

In practice, this usually means a process in which basic data is entered into the computer while a CRT (cathode ray tube) screen constantly displays what is being done. Instructions can then be entered by placing a station point in relation to the geometry already entered; appropriate "commands" then turn the data into a perspective projection on the screen. The basic data may be entered on a keyboard, "keying in" points and lines by their coordinate locations.

One program now in use begins the process by displaying an abstract plan grid. Points are entered and connecting lines called for by keyboard. The grid is given specific scale dimensions, and height dimensions are added in relation to points already placed on the plan grid. This process is not merely entering a drawing, it is generating a three-dimensional "model" of the actual volumetric form. This is the reality that gives CAD perspective its astonishing qualities. Once the "reality" to be illustrated is entered, any view can be produced instantaneously, from any station point location, from any angle.

The views produced are generally "skeleton" or "X-ray" line drawings in which all lines, including ordinarily hidden lines, are visible. This is similar to most manually produced preliminary perspective layouts. Most early programs and many simpler programs now in use are unable to deal with the elimination of hidden lines, but more advanced programs are now available with the capability of performing this step. It is, curiously, a step involving complex logic that requires considerable computer power to perform. In effect, the computer must move a plane back through space, locating solid planes as they are encountered from front to back so that lines and planes that are obscured can be eliminated. It is a step that the human draftsman finds quite simple, but it presents a difficult puzzle to computer technology. With or without hidden lines, the view can be made to change in a continuous way that simulates movement of the object or the viewer in the manner of a motion picture.

Keyboard entry of data and instructions has become commonplace because the keyboard is the most common device for communication with computers in other uses (for example, when dealing with words and numbers), but other means of data entry are now also available. These include an electronic "slate," where touching and moving a stylus produces corresponding imagery on the screen. A "light-pen" can be used to "draw" or make marks directly on the CRT screen by touching it at the desired points. With these means of data entry, it becomes possible to "sketch" freely as one might with pencil and paper, but here the image created is not a single, fixed reality; it is a geometric abstraction that is creating a "model" in the computer of what is drawn.

Still another technique makes it possible to enter information from conventional drawings (typically plans, elevations, and sections) by "tracing" the lines with a movable "cursor" in an entry device called a "digitalizer." Programs are available that will convert the wavering lines of "sketched" data entry to precise, hard-edged equivalents on command.

Skeleton line perspective. An atrium interior (Skidmore, Owings & Merrill, Architects, New York).

Atrium interior, Bank of Montreal. Hidden lines are eliminated and color tones filled in (Skidmore, Owings & Merrill, Architects, New York).

View of theater interior from the stage. White dots are the heads of seated people. Such studies are useful in sight-line and acoustical evaluations (Skidmore, Owings & Merrill, Architects, New York).

View of a theater interior from the rear.

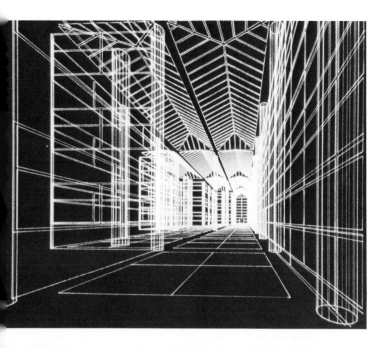

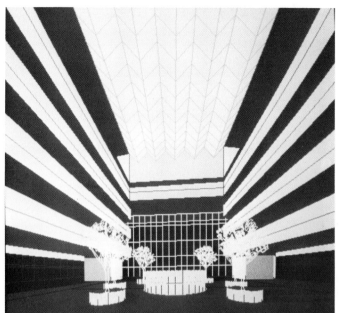

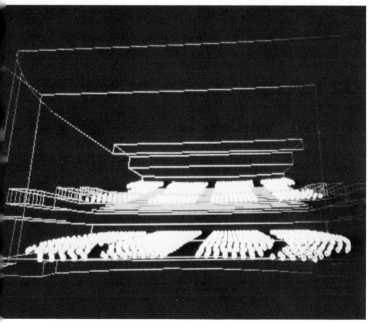

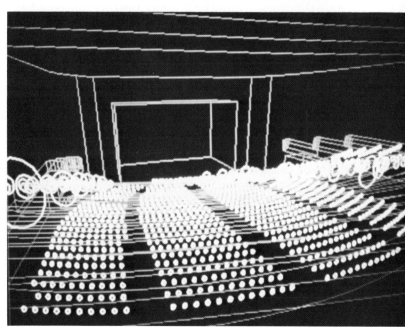

ADVANTAGES OF CAD SYSTEMS

Once entered, data can be altered at will, preserving the original form for comparison or recovery, or discarding it as it is replaced with revised forms. In the same way, the computer-created perspective can be altered, changing viewpoint and angle as required.

Some of the most remarkable possibilities offered by CAD systems include entering data describing a building in some detail, creating a perspective of the total structure from the outside, and then moving up to and into the structure as if "zooming" in a motion picture. Interior spaces can be "explored," as if one were walking through spaces and turning to look in various directions. Of course, displays of this sort take place in "real time" but can be stopped at any point with the stopped image transferred to memory for later recall or printing. Such visual sequences can also be transferred to videotape for storage, replay, and presentation display.

However impressive such displays may be, CAD techniques are most useful in making it possible to develop and modify perspectives, changing either drawing viewpoint or actual design, or both, without time-consuming redrawing. When all design work is done by hand, productivity is often limited because it is so laborious to change one "rough" after another by hand. As desired perspective views are developed on the CRT screen, any view may be "frozen" to be transferred to paper or drafting film when required. The ability to go back and alter a complex drawing at a later date, to add or subtract elements, or make other changes without redrawing the entire sheet has obvious convenience and economic advantages.

CAD techniques are particularly appealing to the interior design fields precisely because the work is often repetitious. The same chair or the same desk may be used again and again within one project or in different projects. Drawing a familiar form over and over endlessly is one of the chores of interior design presentation. A restaurant, an auditorium, or an open office may include a particular object or grouping repeated many times. Computer memory can hold exact

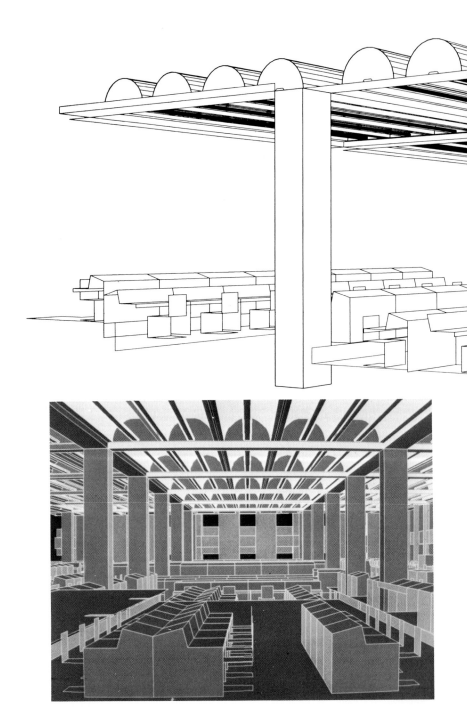

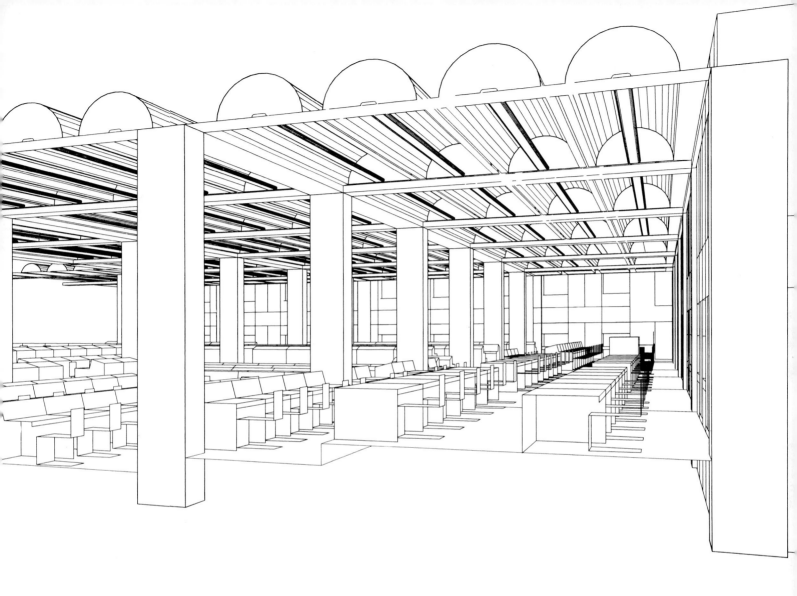

A large ink line plotter drawing (see detail on page 146) of a trading room (Skidmore, Owings & Merrill, Architects, New York).

Another view of the same trading room, here with solid tonal values filled in (Skidmore, Owings & Merrill, Architects, New York).

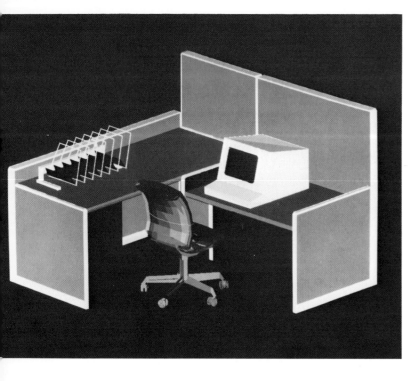

"models" of pieces of furniture, light fixtures, and other elements that are likely to be used repeatedly and can deliver an accurately drawn image at any scale and at any angle of view for insertion into a perspective view under development.

While it is not yet a reality, one can visualize how valuable it would be to have a computer catalogue of images of a vast range of manufactured products in perspective, so that the making of a drawing would simply become a matter of assembly. This could be done with lightning rapidity and with the constantly available possibility of revision, substitution, and relocation of objects.

Effects of light and color can be added into the development of interior representation. With color capability at the CRT screen, areas and objects can be colored for diagrammatic or realistic viewing. The light output of light fixtures can be simulated and displayed, along with the effects of shading and shadows that the relationship of light source to objects will create. One manufacturer is currently offering a program in which the lighting of an interior can be displayed along with calculated light levels expressed in terms of footcandle readings. As with all such computer techniques, the possibility of making changes at the screen on an interactive basis means that the designer can make adjustments and see at once what the effect of each adjustment will be. Problems can be spotted and dealt with with remarkable ease.

Computer display of realistic color still is limited in subtlety and "atmospheric" effect, but a fair simulation of colors of furniture, carpets, and other items is possible, and the ease with which alternatives can be compared makes such techniques useful, even if the results may remain somewhat crude in comparison to skillful rendering or color photography of real spaces. Color print-out also is limited. It is generally easiest to obtain a permanent record of a color screen image by simply photographing the screen—special devices are available to do this quickly and reliably, so that a color slide, film, or TV tape can be obtained.

Screen images are limited in quality by the "resolution" available on a screen of a particular size. All screen images are made up of points of light that are displayed in regular lines or rows of points, rather like the dots of the familiar "screen" in halftone printed images. Solid areas usually appear visually satisfactory, and lines that run horizontally or vertically also appear smooth because they are made up of an unbroken line of points of light. Lines at odd angles are produced by an approximation in which a few points are lined up with steps occurring to make the line seem to slope. The steps are quite noticeable with limited resolution and produce an effect known informally as "jaggies." The larger the screen and the better the available resolution, the less bothersome this effect becomes.

Plotter drawings can produce smooth and perfect lines as in conventional drafting. Dot-matrix printers, often used as a more compact and less expensive alternative to the plotter, are also subject to jaggies, with the roughness of the effect depending on how fine the matrix of dots produced by the printer is.

153

ARE MANUAL TECHNIQUES OUTDATED?

With so many exciting computer possibilities at hand, it might be expected that conventional perspective drawing would become obsolete. Actually, any such changeover is probably far in the future. There are a number of reasons for expecting manual techniques to remain the norm in the foreseeable future. First of all, computer perspective techniques are complex. The complexity may not be troublesome to the user, but it is hidden away in complicated programs that demand large and powerful computer hardware and costly software. This is especially true for the more complex techniques—precisely those that are most attractive and useful.

A powerful computer and a large plotter with the associated terminals and related equipment involves a major investment in equipment, space, and staff to achieve the intended performance results. Given the size of the investment, it takes a large flow of work to keep such equipment busy, and it is only with constant use that the cost of purchase or leasing can be justified. At present, only larger design and architectural firms can afford the equipment and generate sufficient work to keep it in use. In a large office, many terminals with many users can share expensive centralized computer and plotter equipment, but even there, production of working drawings may often take precedence over use for design and presentation.

To some extent, the problems of computer cost and use can be dealt with by using equipment available through agencies that offer computer design and drafting as a service, much as blueprinting or photostating are commonly provided. At present, the problems of going to a remote locale for brief and intermittent use of specialized equipment and the problems of working through a computer operator—a technician familiar with the equipment but not necessarily with the design objectives in hand—tends to limit this way of working on the production of technical drawings. In principle, small terminals in any design office could tie into larger computers centrally located. This approach is widely used for transmission of many kinds of data,

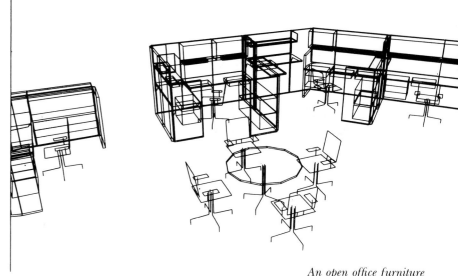

An open office furniture cluster in skeleton outline drawing (courtesy Herman Miller, Inc.).

Another grouping with hidden lines eliminated (courtesy Herman Miller, Inc.).

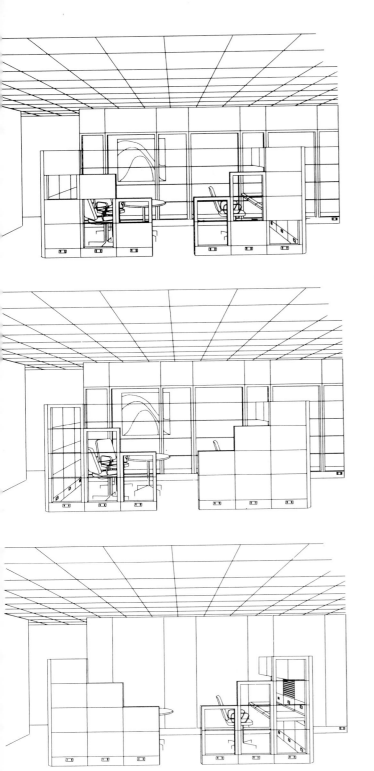

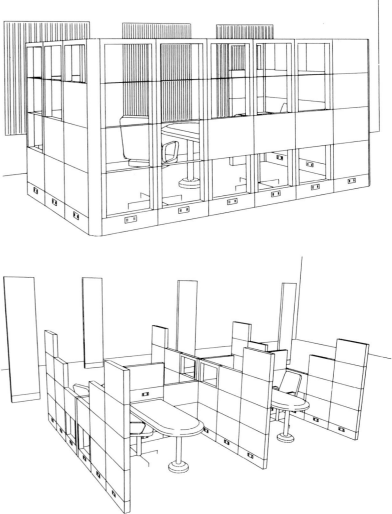

A group of plotter drawings in true one-point, two-point, and three-point perspective. Various groupings of components of an office system. The first three drawings show alternative arrangements of the same basic grouping (courtesy Herman Miller, Inc.).

but the very complex graphic techniques involved in perspective drawing have delayed development of this kind of service.

Some manufacturers now offer services that provide CAD means for planning and specifying certain products—office furniture systems, for example—and the ability to generate perspective drawings is often part of such services. Each manufacturer, naturally enough, only provides programming to deal with its own product line. Problems of compatibility between the services of various manufacturers and the computer equipment that might be available in a design office has also limited the usefulness of such services.

Ideally, at some time in the near future, we may expect a compact and inexpensive computer unit in even the smallest of design offices to have direct communication with the data banks of many manufacturers of all sorts of architectural and interior components and with sophisticated computer centers set up with full perspective drawing capabilities. Given such a network, design in perspective and perspective presentation drawing could become a process largely dealt with at a terminal with printer or TV-tape output the commonly used end products. Plotter drawings could be produced at a remote location and delivered by mail or messenger whenever required.

Aside from the technical difficulties in implementing such a methodology, it must be admitted that there is very real human resistance to moving in this direction. Most designers have been trained to view drawing as their primary means of communication—they have an investment in the craft and a kind of mind-eye-hand coordination in daily use that is not so easily converted to the world of keyboard and screen. There is a strong tradition behind the feeling that a drawing is not only a means to an end, but also an end in itself in which the ideas of the designer can be expressed through subtleties of art-related technique that have, at least at present, no computer-related outlet.

As younger designers move into practice, bringing with them familiarity with the computer that the home and schoolroom computers are now generating, some portion of the present resistance to CAD techniques will probably diminish. Design school training is moving toward increasing inclusion of computer-related courses destined to make the computer no more of a threat than the telephone or typewriter. Even without such background, a designer can become adept at computer perspective techniques in no more than a few days of training followed by a few more days of actual practice. Two weeks will make any willing architect or designer versatile at the computer. However, full "computer literacy," including some knowledge of programming, is another matter—this would call for continuing full-time devotion of a sort that cannot be expected of designers whose focus is on design, not computer technology.

Where the appropriate equipment and programs are available, most designers will find that some use of CAD perspective techniques can be fascinating and productive as a design tool. In producing finished drawings, the computer will be most useful in helping to find a best viewpoint, in dealing with repetitious detail, and in generating layouts that can serve as "base sheets" for overlay drawings made by conventional, hand-drawn means.

Writing with "word processing" has its basis in ordinary manual typing—which in turn is based on writing by hand. Calculation by a computer, no matter how complex, is still based on the calculation that begins with pencil and paper. Computer drafting, too, is simply mechanized (and therefore vastly expedited) manual drafting. Producing perspective drawings with computer aid has its basis in the geometry of perspective drawings as it was first developed during the Renaissance.

Understanding the concepts of station point and picture plane, of vanishing points and horizon are all essential to understanding what a computer can do. What it will produce depends on the instructions given to it and the data provided by the human operators that control it. Therefore, mastery of perspective in its traditional, manually created form is still the only sound basis for making use of the computer to create perspectives.

Selected Bibliography

MANY OF THE BOOKS listed here present a basic perspective drawing method, but interior perspective is not emphasized in most. A number of books have also been included which do not offer methodology, but are collections of drawings or renderings in which interior perspectives are included. A few books that are specially recommended are marked with an asterisk (*).

Bartschi, Willy A. *Linear Perspective*. New York: Van Nostrand Reinhold, 1981.

Capella, Friedrich W. *Professional Perspective Drawing for Architects and Engineers*. New York: McGraw Hill, 1969.

*Ching, Frank. *Architectural Graphics*. New York: Van Nostrand Reinhold, 1975.

Coulin, Claudius. *Step-by-Step Perspective Drawing*. New York: Van Nostrand Reinhold, 1966.

D'Amelio, Joseph. *Perspective Drawing Handbook*. New York: Van Nostrand Reinhold, 1984.

Descorgues, Pierre. *Perspective*. New York: Harry N. Abrams, 1976.

De Vries, Jan Vredeman. *Perspective*. 2nd ed. New York: Dover Publications, 1976.

*Diekman, Norman, and John Pile. *Drawing Interior Architecture*. New York: Whitney Library of Design, 1983.

Diekman, Norman, and John Pile. *Sketching Interior Architecture*. New York: Whitney Library of Design, 1985.

Doblin, J. *Perspective: A New System*. New York: Whitney Library of Design, 1956.

Dubery, Frank, and John Willats. *Perspective and Other Drawing Systems*. New York: Van Nostrand Reinhold, 1972.

Forseth, Kevin. *Graphics for Architecture*. New York: Van Nostrand Reinhold, 1980.

*Gill, Robert W. *Basic Perspective*. 2nd ed. London: Thames and Hudson, 1979.

*Gill, Robert W. *Creative Perspective*. 2nd ed. London: Thames and Hudson, 1979.

Glaeser, Ludwig, ed. *Mies van der Rohe Drawings in the Collection of the Museum of Modern Art*. New York: Museum of Modern Art, 1969.

Izzo, A., and C. Gubitosi. *Frank Lloyd Wright, Three Quarters of a Century of Drawing*. New York: Horizon Press, 1981.

Jacoby, Helmut. *Architectural Drawings 1968–1976*. New York: Architectural Book Publishing Co., 1977.

Jacoby, Helmut. *New Techniques of Architectural Rendering*. New York: Van Nostrand Reinhold, 1981.

Leach, Sid Del Mar. *Techniques of Interior Design Rendering and Presentation*. New York: Architectural Record Books, 1978.

Letarouilly, P. M. *Edifices de Rome Moderne*. Paris, 1825–1860. Various modern reprint editions are available, including one published in 1985 by Princeton Architectural Press, Princeton, N.J. and Bayley, John Barrington. *Letarouilly on Renaissance Rome*. New York: Architectural Book Publishing Co., 1984.

Nevins, Deborah, and Robert A. M. Stern. *The Architect's Eye*. New York: Pantheon Books, 1979.

Oles, Paul Stevenson. *Architectural Illustration*. New York: Van Nostrand Reinhold, 1979.

Pile, John, ed. *Drawings of Architectural Interiors*. 2nd ed. New York: Whitney Library of Design, 1979.

Ratensky, Alexander. *Drawings and Modelmaking*. New York: Whitney Library of Design, 1983.

Vero, Radu. *Understanding Perspective*. New York: Van Nostrand Reinhold, 1980.

Walters, Nigel, and John Bromham. *Principles of Perspective*. New York: Whitney Library of Design, 1970.

Watson, Ernest W. *How to Use Creative Perspective*. New York: Reinhold Publishing Co. 1955.

Worrell, Robert R. *Perspective and Rendering*. Rexburg, Idaho: Ricks College Press, undated.

Index

Edited by Stephen A. Kliment and Naomi Goldstein
Designed by Robert Fillie
Graphic production by Ellen Greene
Set in 10 point Baskerville